Dedicated to the families

of those who lost their lives

on September 11, and to the strangers

who landed among us to become

strangers no more.

National Library of Canada Cataloguing in Publication Data

Main entry under title:
 A diary between friends

Published by McClelland & Stewart and Alliance Atlantis. Alliance Atlantis also
 produced the accompanying television program.
Issued also in French under title: Journal d'une amitié.
ISBN 0-7710-2101-1

1. September 11 Terrorist Attacks, 2001 – Chronology. 2. September 11 Terrorist
Attacks, 2001 – Social aspects. 3. Canada – Relations – United States. 4. United
States – Relations – Canada. I. Canada. II. Alliance Atlantis (Firm)

FC2491.D52 2002 973.931 C2001-903992-1
F1029.5.U6D52 2002

The images in this book were gathered from a variety of sources, including wire
services, newspapers across the country, and public and private collections. For a
complete list of these, consult the index, beginning on p. 142. The text has been
gathered from the Internet, public sources and through interviews. (Editor's note:
Spellings appear as written. For example, "neighbor" [American] and "neighbour"
[Canadian.]) All effort has been made to contact the individuals quoted in this book.

McClelland & Stewart acknowledges the financial support of the Government of
Canada through the Book Publishing Industry Development Program for our
publishing activities. M&S further acknowledges the support of the Canada Council
for the Arts and the Ontario Arts Council for our publishing program.

Printed and bound in Canada

McClelland & Stewart Ltd.
The Canadian Publishers
481 University Avenue
Toronto, Ontario
M5G 2E9
www.mcclelland.com

2 3 4 5 6 06 05 04 03 02

10-17-01
Sad yet resolute, a five-year-old girl clutches her father, Seaman Kelvin Henebury, cheek-to-cheek as he prepares to sail from Halifax Harbour, Nova Scotia, aboard HMCS Preserver *en route to the Persian Gulf.*

A volunteer gives away so much of his bed linen to stranded air passengers that he has nothing left at home. A grateful planeload of passengers funds a scholarship for the small Newfoundland community that came to their aid. Schoolchildren scrape together all of the pennies they can find to support grieving families. High-rigging Mohawks travel to New York to dismantle the World Trade Center that they had helped build. A little girl holds on tight to her daddy as he gets ready to head off to sea with the Canadian Armed Forces. One hundred thousand Canadians gather on a brilliant autumn day on Parliament Hill in Ottawa to express sympathy and solidarity with the people of the United States.

Such images and stories — and many, many more — have been engraved on our collective memory since the awful events of September 11, 2001.

A Diary Between Friends is a visual and written expression of a friendship of profound depth; a friendship between two nations — Canada and the United States — which has been renewed and reaffirmed, in words and deeds, in the crucible of the worst terrorist attack in history.

Canadians responded because the attack was an offence against the values of freedom, tolerance and respect for cultural diversity that are the cornerstones of our nation. We responded because we intuitively understood that this was an assault not just on the United States, but against all civilized peoples and nations. But, above all, we responded out of common human decency; out of the belief, put with simple eloquence by a Canadian steamfitter on the way to Ground Zero to help with the recovery effort, that "A friend in need, is a friend indeed."

Of course *A Diary Between Friends* could never hope to be an exhaustive account. Many stories will live on quietly in the hearts of those who gave and received kindness and compassion. It stands as a diary of the extraordinary response of a nation to an unprecedented event. It is a meditation on what it truly means to be neighbours, to be friends and, indeed, to be family.

Jean Chrétien

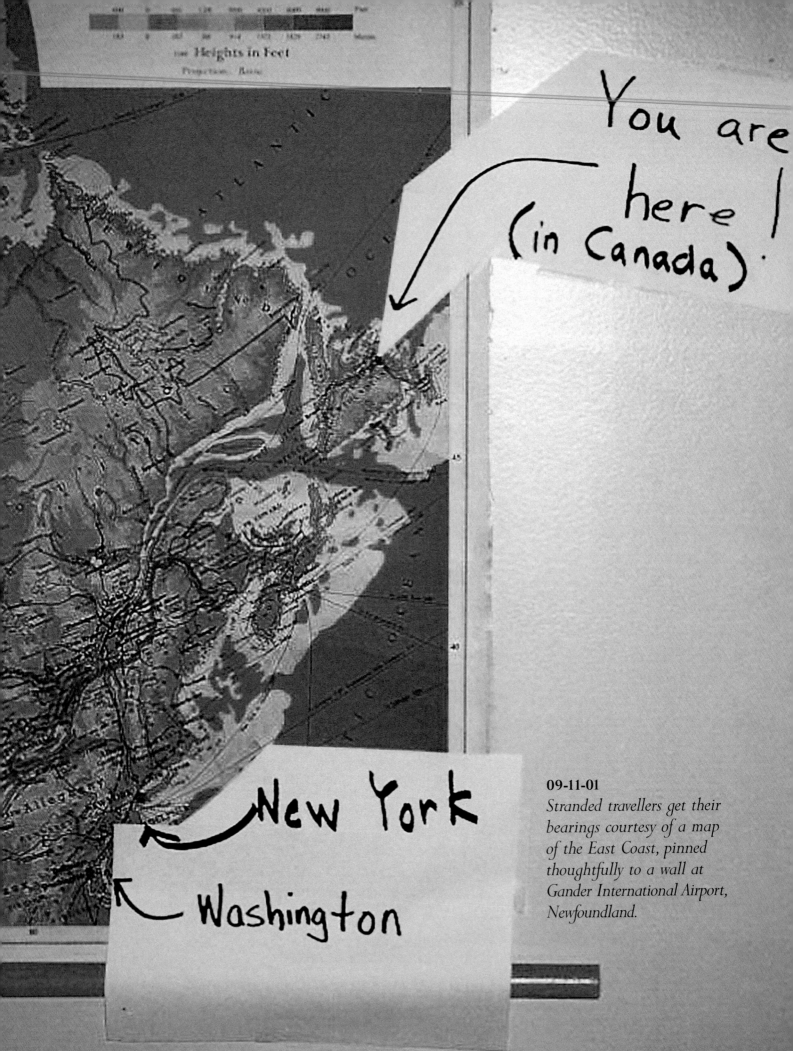

09-11-01
Stranded travellers get their bearings courtesy of a map of the East Coast, pinned thoughtfully to a wall at Gander International Airport, Newfoundland.

September 11 2001

Soon after the events of September 11, this story — attributed to a crew member from one of the more than 200 planes diverted to Canada — spread like wildfire over the Internet. We don't know who the author is, but we have researched the fundamental facts and found them to be true. They are the same details that comprise endless stories told by stranded airline passengers and crew about the people of Newfoundland and their compassion.

THE PLANE WAS FLYING over the North Atlantic on its way back to the U.S. when the captain instructed the entire crew to report immediately to the cockpit.

The look on the captain's face was "all business" as he handed over a printed message — "All airways over the continental U.S. are closed. Land ASAP at the nearest airport, advise your destination."

When a dispatcher instructs a flight crew to land immediately without suggesting which airport, one assumes that he or she has reluctantly relinquished control to the captain. It was a serious situation and the aircraft needed to find terra firma quickly. The nearest airport was at Gander, 400 miles away on the island of Newfoundland in Canada. At the request of the Canadian traffic controller, the aircraft made a right turn directly to Gander. The reason for the request would only later become evident.

The cabin crew were told to get the airplane ready for an immediate landing. While this was going on, another message arrived informing the cockpit of the terrorist attacks. The rest of the crew was briefed, but the passengers were not.

At 12:30 local time (11:00 a.m. EST), approximately 40 minutes after the start of this episode, the plane landed in

It was a serious situation and the aircraft needed to find terra firma quickly.

Gander, and sat alongside about 20 other airplanes from all over the world. The captain then made an announcement telling the passengers of the situation.

There were loud gasps. Meanwhile, Gander control told the crew that no one was to leave the aircraft, and no one on the ground was allowed to come near it. From time to time the airport police would drive around to inspect. In the next hour or so, as all the airways over the North Atlantic were closed down, Gander alone received more than 50 airplanes from all over the world, of which at least half were flying the American flag.

Then it was announced that every plane was to be offloaded, but one at a time. Soon thereafter the passengers were told for the first time about the hijacking

and the attacks on New York. Those on board scrambled to use their cell phones, but most were unable to get a connection. Those who did get through to a Canadian operator were told that lines to the U.S. were either blocked or jammed.

Sometime late in the evening, news filtered through that the World Trade Center buildings had collapsed, a third hijacked plane had attacked the Pentagon, and a fourth airplane had crashed in a field in Pennsylvania. By now the passengers were totally bewildered and emotionally exhausted, but they stayed calm, especially as the crew kept reminding them there were more than 50 other planes in the same predicament.

At 6 p.m., Gander airport told the crew that no one would be getting off that plane until 11a.m. the next day.

The passengers accepted this news without much complaint and prepared to spend the night on the airplane. Gander had promised any necessary medical attention. The crew kept busy tending to a young woman who was in her 33rd week of pregnancy, and despite the uncomfortable sleeping arrangements, the night passed without incident.

At 10:30 a.m. on the 12th, a convoy of school buses arrived at the side of the airplane. The stairway was hooked up, and the passengers were finally taken to the terminal for "processing." No one knew what to expect.

The town of Gander, which has a population of about 10,000, was expecting about 10,500 passengers from all the airplanes that were forced to land there. The crew was sent to a hotel and told to wait for a call to go back to the airport, but not to expect that call for some time.

Only after getting to the hotel and turning on the TV, 24 hours after it all began, did the crew learn the magnitude of the events back home. In the meantime they tried to distract themselves by walking around town and enjoying the hospitality of a friendly people that referred to them jovially as "the plane people."

Two days later, on the 14th, the call to go back to the airport came. At 12:30 p.m., the airplane left Gander to continue its journey home.

But that's not the end of this story. On board the plane, the passengers shared, with each other and the crew, uplifting accounts of their time on the ground. Gander and the surrounding small communities, within a 75-kilometer radius, had closed all the high schools, meeting halls, lodges and any other large

The town of Gander, which has a population of about 10,000, was expecting about 10,500 passengers from all the airplanes that were forced to land there.

09-11-01

Eyes rivetted on a television screen, waylaid passengers at Halifax International Airport contemplate the unfolding horror of September 11.

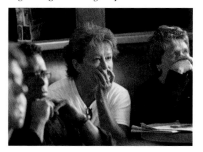

09-11-01
*Keeping a watchful eye
on the surrounding planes,
an American Airlines pilot
peers out his cockpit window
at the unscheduled jam
of wide-bodied jets on
the tarmac at Vancouver
International Airport,
British Columbia.*

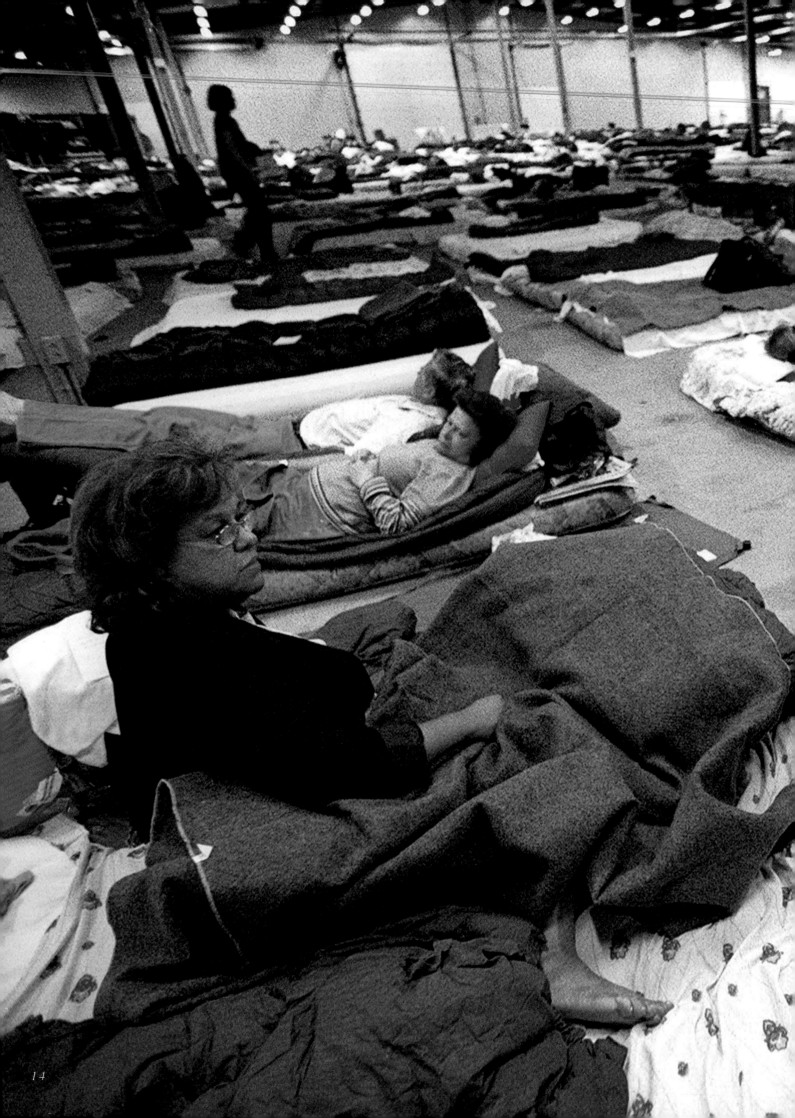

09-12-01
Miami resident Melua Padilla supervises her husband Julian's attempt at mending her slacks amidst the hundreds of transient passengers sleeping over in their impromptu residence at Halifax's Exhibition Park.

Why all of this? Because human beings in a far-away place were kind to strangers who, in tragic circumstances, literally fell in upon them from the sky.

09-11-01

Exhaustion shows on the face of an Asian traveller, one of many ferried by school bus to a community centre in Richmond, British Columbia.

gathering places and converted them into mass lodging areas. In some, cots were set up; others had mats with sleeping bags and pillows. All the high school students had volunteered to take care of their "guests."

The 200-plus passengers of this flight ended up in a town called Lewisporte, about 45 kilometers from Gander. There they were billeted in a high school. If any women wanted to be in a "women-only" facility, that was also arranged. Families were kept together. All the elderly passengers were taken to private homes.

The young pregnant woman stayed in a private home right across the street from a 24-hour emergency care facility.

There were doctors on call, and with both male and female nurses available. Phone calls and e-mails to the U.S. and Europe were available for everyone once a day. During the days, the passengers were given a choice of "excursion" trips. Some people went on boat cruises of the lakes and harbors; others went to see the nearby forests. Meanwhile, the local bakeries stayed open to make fresh bread for the guests. Food was also prepared by all the residents and taken to the school for those who elected to stay put. Others were driven to the eatery of their choice and fed. Since their luggage was still on the aircraft, they were given tokens to go to the local laundromat so they could wash their clothes. In other words, every single need was taken care of.

After all that, they were delivered to the airport exactly on time and without a single one missing or late because the local organizers had all the information about the goings-on back at Gander and knew which group needed to leave for the airport at what time. When the passengers came on board, it was like they had been on a cruise. Everybody knew everybody else by their first name. Telling their stories, they were laughing and crying. They were swapping stories and impressing each other with who had the better time.

The trip back looked like a party flight with the passengers exchanging phone numbers, addresses and e-mail addresses. And then a strange thing happened. One of the passengers approached and asked to speak over the PA system – something that is never permitted! But under these special circumstances, the crew member said "of course."

The passenger picked up the PA and reminded everyone about what they had just been through over the last few days; reminding them of the hospitality they had received at the hands of total strangers, further stating a desire to do something in return for the good folks of the town of Lewisporte. He proposed a trust fund to provide a scholarship for the high school students of Lewisporte, to help one or two of them to go to college every year, and he asked for donations of any amount from his fellow travelers.

When the tally was complete with amounts, names, phone numbers and addresses, it totaled $14,500. The passenger who had proposed the fund promised to match the donations and to start the administrative work on the scholarship. The proposal was to be sent to the airline's head office with a request that they too make a donation.

Why all of this? Because human beings in a far-away place were kind to strangers who, in tragic circumstances, literally fell in upon them from the sky. ∎

09-11-01
Stranded passenger Pauline Dosley is comforted by her mother, Joanne, at Calgary International Airport, Alberta.

09-11-01
Blankets piled up at one
end of a hockey arena in
Moncton, New Brunswick,
offer the promise of rest
for the "plane people."

"As a native of Gander, I am very proud of my little town, which has always been known as 'the crossroads of the world.' My dad told me of how he opened his home to several people that week. From a proud son, thank you, Dad. You are still to this day teaching me the true meaning of love."
—B.J., Gander, Newfoundland

"We'll never forget hearing our Canadian neighbors sing the 'Star-Spangled Banner' at a memorial service, seeing a child's drawing of the U.S. flag with 'God Bless America' scrawled next to it, the woman who ran around the counter and hugged us when she learned about our origins."
—Tom, Fairfield, Connecticut

"Waiting for a Plane" is written by Julian Dawson, who played the guitar and sang without repetition for the six days he was stranded in Gambo, Newfoundland (a repertoire of more than 100 songs).
(Sung to the tune of "Waiting for a Train")

"All along the waterfront
Waiting for a plane
A thousand miles away from home
We should be plum insane
But our plates are never empty
Lord they're feeding us again
A thousand miles away from home
And waiting for a plane

I pulled up to a pick-up truck
Just to make a line of talk
They said no need to be bored my friend
We've organized a walk
Well we may be here a week or two
But you've taken away the pain
We feel right at home in Gambo
And we're waiting for a plane

We're sleeping in a church here
Like we've never done before
We're stretched on cots and benches
Some sleeping on the floor
We're heading for the Guinness Book
For the all-time loudest snore
It's great terrain
We're full again
Been a little rain
But we're taking the strain
A little insane
But in the main
We can't complain…
We're just waiting for a plane

Now we're back in our own world
We've left the trees behind
Older and somewhat wiser parts
Of this mess we call mankind
Now everything looks different
In ways we can't explain
We've seen the best that we can be
While we were waiting for a plane"
—Copyright © 2001 Julian Dawson
www.ua929.org

"At least once a day, our 'experience' comes up in conversation and I am asked to tell the story. I start out enthusiastically, and after a minute or two I start saying, 'You wouldn't believe it, you wouldn't believe it,' and then I just quit because I cannot find the words to convey the feeling…. I wish I could somehow gather the emotion we felt — a combination of fright, fatigue, generosity, kindness, unselfishness, humor and so much more — and put it in a bottle. I would open the bottle whenever anyone wanted to hear 'the story' and tell them to breathe in deeply. It would be a much better world."
—Jackie Pinto, New York City, New York

"I wish I could somehow gather the emotion we felt…and put it in a bottle. I would open the bottle whenever anyone wanted to hear 'the story' and tell them to breathe in deeply. It would be a much better world."

09-11-01
Resting easy, a passenger peruses the Moncton Times and Transcript *in New Brunswick (top).*
09-13-01
Two others decide to sleep out under a Newfoundland sky at St. John's International Airport (bottom).

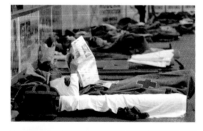

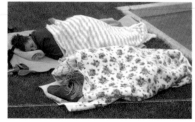

"There were at least one hundred small incidents of beautiful human kindness that I witnessed over the three days that I cannot express, except to say that they are the gold standard of humanity."

09-15-01

Stranded passengers receive birthday wishes and several cakes from the town of Gander, Newfoundland (top). At Gander, the Newfie tradition of "kissing the cod" is a handy prop for light banter (bottom).

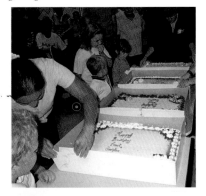

"I've been a pilot for more than 20 years, and I've been personally – sometimes painfully – involved in aviation safety for 15 of those years....You could have pleaded an inability to help beyond the basics; you could have tried to limit the burden to 'first come, first served,' or 'women and children first,' but you didn't. Instead, you turned a terrible day into a remarkable affirmation of humanity and compassion. We Americans watched, often in surprise and occasionally in disbelief, as one nation's leaders after another firmly stated, 'We are all Americans today.' In return, I'd like to say this: I would [have] it that everyone in the world be Canadians – Newfies – if that meant seeing such a spirit of unique generosity and kindness encircle the Earth."

–Tom

"Our initial feelings were fear, being separated from our friends and family, [but] we became quickly overwhelmed by your unexpected and more than generous hospitality. In hindsight, we cannot think of a better place to have been during the week following the horrible events of September 11 than in Gander. While many Americans experienced only the evil, we were blessed to land among people who welcomed us with open arms anticipating our every need....You taught thousands of people from all over the world how to care for strangers."

–Caroline, Philip, Helen and Hannah Dennis, Decatur, Georgia

"At three in the morning we found the good people of Appleton awake with food, coffee, bedding, television and kind, sympathetic words for all of us. This was followed by so much kindness in the form of...hikes through the woods, even homemade brew, boat rides and many, many laughs. The laughs were so important in reversing some of the despair of the tragedy and being stranded far from home and feeling vulnerable. The spirit in which they took care of us was the most inspiring because they did everything in a way to make you feel that it wasn't a burden on them. I knew that they had closed their schools and many businesses just to attend to our needs.

Another example of the kindness was the pharmacy that provided our medication at no cost and told us the Red Cross is paying for it. And once I was in a small store buying some simple supplies and was a dollar short, and more than one of the other customers offered me the extra amount, knowing that I was one of the 'plane people.'... There were at least one hundred small incidents of beautiful human kindness that I witnessed over the three days that I cannot express, except to say that they are the gold standard of humanity."

–David Korpan, New York City, New York

"The experiences we had in Gander at the Masonic Lodge gave us hope for the future of our troubled world. I am infused with 'Gander Generosity and Goodness' and have tried to treat everyone I encounter with the same spirit that you all showed to us."

–P. and J.B.

"We were guests in your homes, your coliseum, your hotels, but we were treated as if we were family that you had not seen for some years. You gave us shelter, food, clothing, information, phones, medicine, but most of all, our honor that we were Americans. Thank you."

–John C. Bobbs, McKeesport, Pennsylvania

A Diary *Between Friends*

09-12-01
A stranded passenger's attempt to rebook his flight is put on hold at Pearson International Airport, Toronto.

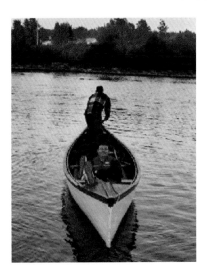

09-13-01

Passing the time while stranded, Victor Munro of Staten Island, New York, is treated to a canoe ride on the Gander River.

"How does a person say 'THANK YOU' to a NATION?"

09-11-01

An American flag flies over the Gander control tower, placed there by local air traffic controllers in memory of those who died on September 11.

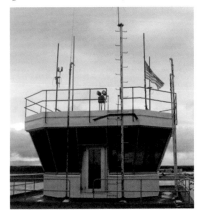

"We placed an American flag on top of the air traffic control tower to show our respect. I am not an American, but it sure looks and feels good to fly it for a few days."
—*Ken Arsenault, Gander air traffic controller*

"Although this world reminds us daily that evil exists, you have surpassed the impact through all of your kindness and service. May God bless and keep you all."
—*Jennifer K. Hrometz, Statesville, North Carolina*

"How can I ever express our gratitude for the outpouring of love, kindness, caring words and work that you and all the good people of Moncton showered upon us? I have always felt that God sends Angels in the form of humans to care for one another in time of great need. The Angels of Moncton gave us love, caring words and food in our time of need."
—*Pat Leaberry, Huntington, West Virginia*

"I know I can speak for all of the stranded passengers when I say that you shaped what should have been an unbearable situation into something we will never (for the better) forget. I will tell you that as the plane taxied away from the terminal on Thursday night, there was a universal cheer of gratitude and many tears of sadness at leaving all of you."
—*Justin Zackham, Los Angeles, California*

"My husband and I were among the 1,500 uninvited guests that flew into your community on September 11. We know you must have been exhausted by the time we all left, but your hearts must have been bursting with pride — you truly proved that the whole world is one large community and we have to take care of one another when people are in need.…GOD BLESS YOU ALL…. Again, thank you, thank you, thank you!"
—*Kay and Dennis Anstine, Canton, Ohio*

"Seeing the way you have pulled together to help my fellow Americans left me trembling and in tears. My heart is overwhelmed at the outpouring of Canadian compassion to stranded Americans. How does a person say 'THANK YOU' to a NATION?"
—*Letitia*

"Hello from Omaha, Nebraska. Please, let all the Canadian people know how much we appreciate their kindness and support. God bless you all and GOD BLESS AMERICA."
—*Julia McShaw, Omaha, Nebraska*

"Thank you! As an American in the State of Kentucky I want to express my grateful appreciation on behalf of myself and all Americans. I would be proud to stand side by side with you at any time!"
—*B.D.*

"Your people opened up their hearts, and rolled out the red carpet to so many folks.…I was one of the lucky ones, I got the phone call, 'Mom, it's Deb, we're all right.' Thank you from a very grateful heart."
—*Elie Creamer, Virginia Beach, Virginia*

"Words fail me to describe the reception and care given us during our recent involuntary stay at Gander. Considering the circumstances, your town and its inhabitants rose to this tragic occasion, caused by the terrorist attacks in the U.S.A. Your hospitality, your aid, shown to us by so many residents of Gander, was simply heartwarming. My wife, Lore, and I (who

incidentally landed at Gander once before in 1949 under different circumstances) wish to express our gratitude to you, to the many volunteers and the schools, which helped to make our stay possible. Thank you again and kind regards."
—*Ret. Lt. Col. (USAR) Leo Baer and Lore Baer, New York City, New York*

"With Gratitude,
The entire U.S. Customs Preclearance staff wishes to publicly express our gratitude and appreciation for the many kind expressions of goodwill and support that we have received since the terrorist attacks on September 11.

Canada has proven to be a good friend and neighbor during America's time of need. Faced with an unexpected aviation emergency that was unimaginable in a time of peace, Canada showed the world what she was made of. Canada opened her skies, her airports, her arms and her heart when America needed her most."
—*U.S. Customs Edmonton Preclearance, Edmonton International Airport, Alberta*

"Last week, I heard an interview on national public radio about the flight diverted to Gander on September 11. On my way home from work, in our typical rush hour traffic, I wept at the thought of your small community providing shelter and comfort to thousands of confused and frightened passengers. The strain on your resources must have been enormous, but you and the citizens of Gander handled the emergency with organization, calm and compassion.

I wish to express my heartfelt thanks to the good people of Gander. Although I do not know anyone who benefited from your many acts of kindness, the hospitality

of Gander's citizens serves as inspiration to me personally, and makes me very proud of our neighbors to the North.

Not only are the many Americans drawn together in our grief, sadness and fear, we are all drawn together as citizens of the World. The distance among us diminishes with each act of compassion and draws us together to celebrate the goodness of humanity in the face of those who wish to destroy it. Thank you so very much and may God bless Canada."
—*Linnea Hull, El Dorado Hills, California*

"I could write volumes about the love, generosity, compassion and warmth of the Canadian people who housed us for three days, in a small town called Gambo, south of Gander, Newfoundland.

We were told while in flight over the Atlantic only that 'there is a terrorist threat, and we have been ordered to land in Canada.' After first being assigned to St. John's, later Goose Bay and finally Gander, we landed on Tuesday morning, around 11:30. Only after landing did someone have a very small radio, and we were all barely able to listen to a small station broadcasting out of Gander, and began to get the news.

We were held on the plane for another 26 hours (that's a total of about 32 hours on the plane), not getting off until about 1:30 the next day.

The crew was excellent, somehow serving us throughout the 26 hours on the tarmac — although we were largely out of food, obviously. I was proud of the people on our flight — they all kept a good attitude and maintained their composure. There were between 38 to 41 planes on the ground, and each evacuation took about two hours.

09-11-01
High School students in Sackville, Nova Scotia, (top) and in Gander, Newfoundland, (bottom) sort food donations for the welcome, if unexpected, visitors.

"Canada opened her skies, her airports, her arms and her heart when America needed her most."

09-11-01

A child stranded at Edmonton International Airport depicts the crowded conditions created by the flight diversions that brought her there.

09-14-01

A mother and child look happy enough to be stranded in Gambo, Newfoundland.

"The bus drivers were on strike. They 'set down their pickets' to help out. Most of them had been up for over 30 hours."

How these people came up with those kinds of supplies and food is beyond belief.

Ultimately, we were bused to the small town of Gambo. The schools had all been closed, and the bus drivers were on strike. However, they 'set down their pickets' to help out. Most of them had been up for over 30 hours.

I could write a book about the treatment we received in the town of Gambo. As we later found out, the same hospitality and love was found in every small town that everyone was taken to. We were housed in private homes, two churches, the Salvation Army, a volunteer Fire Department and the Fisherman's Lodge. I was in St. George's Anglican Church. The folks in this town had been up all night gathering pillows, blankets, mattresses, sleeping bags, food, homemade jelly, bread, etc. The two small stores simply opened their doors all night long and told the community to 'take what you need.'

In short, love, untold generosity, compassion and warmth surrounded us.

Every meal was a feast. I gained 28 pounds. Friendships have been struck, not only amongst flight members, but probably more so with members of this wonderful, idyllic little community. The community was in a postcard seaside setting

For two wonderful days and evenings, we were treated like royalty. The people were so compassionate and truly caring, not only because this had happened to our country, but also because we had been stuck here.

The school was made into a 'command center.' We were given clothes — from underwear to sweaters. First aid and counseling were provided and every personal need was met. The two computer labs were turned over for our use — providing e-mail access and Internet connections.

On Thursday, a wonderful church service was organized and held at 'our' church. The bells rang, and the entire community turned out. It was a very moving and emotional experience. There were probably people from at least 10 nationalities there.

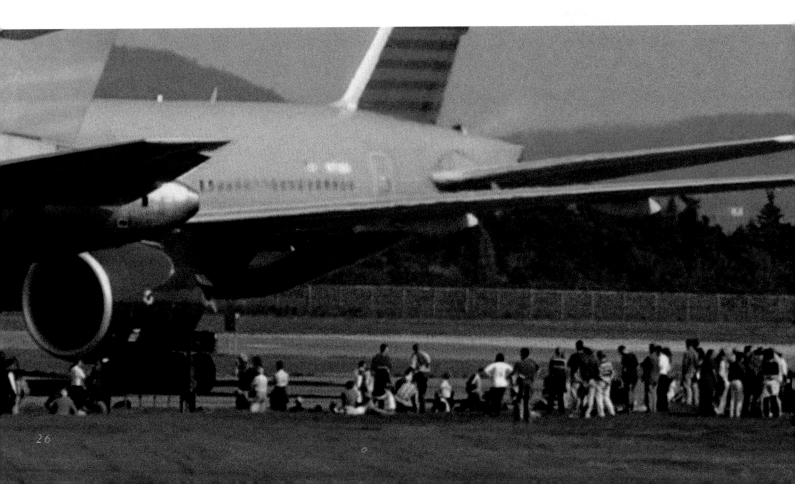

After many mixed messages, we were finally given the okay to board the buses on Friday morning. A wonderful, wonderful gentleman had written a poem, which he read to us before we all got on the bus. Once we were all on the bus, the people of the community lined the streets, blowing kisses, but mostly cheering and crying. As badly as we wanted to get to the airport for our eventual flight home, we also did not want to leave this wonderful town and these wonderful people....

All through this, one of my main thoughts was that in spite of the horrible tragedy that had occurred, we have to remember that the world is still populated by good, decent and wonderful people. How sad it is that it takes something like this for all of us to be reminded of that simple fact."

—Steve

"My husband and I spent six days stranded with the most saintly, loving, giving, compassionate people we have ever known. As I write this I don't know what our fate will be. But I do know this: If there is a heaven on earth, it is in Gander. God brought us to you. It was no mistake, it was not luck. Your actions and your faces will remain engrained in our memories forever. To say we made friends in Gander would be an understatement. You made us feel like family."

—T. and B.S.

"You and your fellow townspeople swung into action, opening their hearts and their homes and making us very much at home despite our being stranded. Many thanks to the people of Moncton from your neighbors to the south."

—Robert J. Simonds, Carbondale, Illinois

"The people of Lewisporte showed us incredible concern and genuine love.... We've made friendships that will last as long as we live."

—Delta 15 passenger Shirley Brooks-Jones, Columbus, Ohio

09-11-01

Putting the concept of sanctuary to good use, airline refugees sleep between the pews at St. George's Anglican Church in Gambo, Newfoundland.

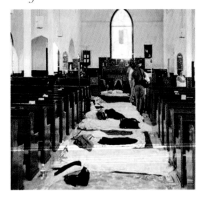

09-11-01

More than 200 passengers from an already stranded United Airlines flight gather on the tarmac at St. John's International Airport. They were forced from their plane by a bomb threat.

09-11-01
A security guard at Toronto's Pearson airport strikes a stalwart pose while French-language monitors above reveal the gravity of the situation.

09-11-01
Seeking spiritual guidance in the face of the inexplicable, a Calgary International Airport employee, Robyn Peppinck, takes a moment to pray at the Aviation Interfaith Chapel.

> "One teenager, a boy, was serving coffee. I'd seen him the night before doing the same thing, and I asked if he wasn't exhausted.... That one boy I remember was there every single morning."

09-11-01

Stranded passengers in the departures lounge of Vancouver International Airport stare at television screens in disbelief.

Diana Feibelman, along with her husband, was en route home from Brussels to Miami, Florida, on September 11. She was one of the thousands of American passengers who landed at Gander, Newfoundland, nearly doubling the town's population during an unexpected five-day stopover.

"AT FIRST NONE OF US KNEW what or where Gander was. The scene on board the plane was chaotic. We were all trying to use the phones, everyone swiping their credit cards and nobody getting through. All I could think was, for the first time, my kids were left home alone and I was terrified not to be with them.

Sitting on the tarmac in Gander for what seemed an eternity, odd yet strangely touching things started to happen. We learned that we had a pregnant monkey in the cargo section and she was going to need assistance. The crew were determined to take care of that monkey. And there was a newly adopted kid on the plane who was traveling to meet his new family for the first time. A stewardess took that child under her wing, and eventually when we got off the plane she took him directly to a local family's home so he could get in touch with his new parents.

The rest of us were taken from the plane to a school: The Gander Academy. We dubbed it 'The Hotel Gander.' We were welcomed, taken to the gym, given blankets and provided with four phones and 12 computers. Though I had to wait until 2:00 a.m. to e-mail the kids, I started to feel reconnected with the world. I managed to sleep a few hours on the floor mats in the gym. By now the passengers had become fast friends, and we were all sleeping side by side. That was day one.

Day two I was up at 6:00 a.m. I went upstairs to an assembly hall, where I saw all these women serving eggs and toast. One teenager, a boy, was serving coffee. I'd seen him the night before doing the same thing, and I asked if he wasn't exhausted. The local kids were unbelievable, cleaning washrooms, sweeping between our mats in the gym, serving food. That one boy I remember was there every single morning.

There was no news as to when we would be departing, so I decided to take a shower. I was given a towel, toothpaste, brush and contact lens solution – they had absolutely everything there for us, we didn't want for a thing. However, since our luggage was still on the plane, a group of us decided to go for a walk downtown and buy some clothes. Everyone we passed in town was so nice, saying good morning and asking if we needed anything. The weather was perfect. So even with our natural fears and frustrations I started to feel safe. My major purchase in Gander was two jogging suits, underwear and socks. I think it came to $60 American, but before I could pay, the cashier said they were having 'a special' for all the visitors to Gander that day. Incredible!

After shopping, we went back to the school, and I saw this man moving pretty fast and figured he must be running the show. His name was Dennis Russell. I told him I thought he was doing a great job and if he needed a hand to let me know. He told me that he was co-ordinating meals for all the shelters. 'By the way,' he said, 'have you seen any of Gander yet?' I told him not yet but that it would be nice. I thought nothing more of it.

On the third day, Dennis proved to be as good as his word. First he took us to the memorial at the crash site of the last

plane to come back from the Gulf War. Then we visited Gander's new hockey arena. It wasn't being used for hockey though. All the perishable food supplies for the stranded were being kept cold on the ice. As the food arrived it was sorted: milk, yogurt, vegetables and everything else you could imagine. They had people roaming the ice inspecting the expiration dates to make sure nothing went bad.

After the tour, a woman at the school offered her house for us to shower and do our laundry in. She gave us robes, and while we showered she washed our clothes. I was overwhelmed. I think of myself as a good lady. I cooked for people during the hurricane in Miami. But when I look back I don't think I ever would have invited people into my home and done their laundry. Now I would.

By day four we told our kids it looked as though we might be flying home the next day. The captain told us we'd be given four hours notice of our flight leaving, so we decided to visit Twillingate, a small fishing village about an hour's drive northeast of Gander. It was a beautiful ride. I told my husband I could retire here and rest easy. They even had fresh blueberries, which I ate right off the bush. But the best was when we stopped at the Anchor Inn Motel. The chef had left for the afternoon just minutes before. We told the waitress how hungry we were, and she got right on her cell phone, called the chef and he actually returned to make us lunch. How nice was that!

Later in the day I returned to the school because I realized I didn't have any more of my anti-anxiety drugs I need for flying. The nurse on duty at the school said she would send a runner to the drugstore and that I should wait for a bit and they'd have the Xanax for me. I went downstairs to the gym to see if anyone was around, and there was a woman and a gaggle of kids making peanut butter and jelly sandwiches. There were four tables covered with sandwiches. I gave them a hand, and as I was sitting there, I started thinking about my own kids, about how we used to make peanut butter sandwiches at the Temple on Sundays for the homeless, and about how – despite this nice little community of stranded people that had sprung up here – I'd really rather be home with them.

Five days after the horrors of the 11th we were on our way home. Right after lift-off, everybody up in business class made a round of celebratory martinis with the vodka I'd purchased at the Gander duty-free shop. All the talk on the flight was that there wasn't one of us, not one, who hadn't had an extraordinary experience in Gander. And when I got back to Miami, I called all the other people I knew who had been on the same business trip to Brussels but had returned on different flights. We all started going on about how beautifully we'd been taken care of, and then we realized we had all been in Gander but didn't know it at the time – one was at the church, another at a bowling alley and I was at the school. We all shared the same thought: Were those people for real? They went way, way, way beyond what was necessary. There was never anything that any of us wanted for. Money was never an issue. We didn't pay for a meal. Home-cooked meals were brought to the shelters daily, and they were better than at a restaurant. Never had we met such great people with such big hearts. The whole world should take a lesson from the people of Gander." ∎

"The only person I had time to call was my husband. I told him I was in Gander but I couldn't get in touch with my sister Sheryl. My husband told her roughly where I was, so she called the Gander police. She got Ozzy Fudge, a policeman, on the phone. She told him as best she could where I was, and asked him to do her a favor – would he please find me and give me a hug. He said, 'Sure. Stay on the line with me, I'm here on my cell phone.' He drove right over. But I wasn't there. He left me a note and I went looking for him. But I didn't find him, so I went back, and there was another note, this time with a police department baseball cap and his phone number. I called him and he said, 'Don't move. I'm on my way.' Within five minutes he was there. He got out of his car and gave me the biggest hug you've ever seen. He said, 'That was from your sister.'"

—Sharlene Bowen, a Delta Airlines flight attendant from Atlanta, Georgia

09-16-01
*Their painted faces sombre,
eight-year-old Kristen and
her seven-year-old friend
Haley attend a fundraising
concert held in Sidney,
British Columbia, for children
affected by the events of
September 11.*

Mourning and Support

Rabbi Neal Rose, a family therapist and senior scholar at the University of Manitoba, was one of several religious leaders to speak at an interfaith memorial service in Winnipeg, Manitoba.

"THE MORNING FOLLOWING THE ATTACKS I was in a state of shock. I was frightened. I was confused. I wondered where the world was going. I was searching to reconnect with something, a sense of goodness and a sense of strength.

My wife, Carol, and I have two children who live in New York. We knew when it happened there wasn't much chance they were in the area. But there was always that possibility. And we have two nephews who work in or around the towers. One was there when it happened. He was in a building next door. He was sitting at his desk and looked out the window. He said to the guy next to him: 'I cannot believe what I just saw.'

After discovering that our family members were safe, the broader implications dawned on us. We were concerned about the repercussions for the various religious communities involved. Soon the mayor's office called. They shared our concern: that with all the diversity in Winnipeg — a very multicultural city — there was a pressing need to rebuild a communal sense of confidence and security.

The planning for an interfaith memorial service began immediately. On one level it was about Canadians offering condolences to Americans, a statement of the unity between our two nations. The memorial also sought to provide a context for mourning, a framework for interpreting the tragedy. We needed to talk about our pain and our concern for one another. And, just as importantly, we needed to talk about our fear — fear that

09-14-01

Among Canadians paying their respects on Parliament Hill in Ottawa during the National Day of Mourning, Leah Anderson rolls out the Stars and Stripes near the Centennial Flame.

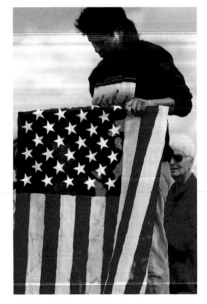

09-14-01
*Two-year-old Naseeb
attends a Muslim memorial
prayer service in Calgary,
Alberta, on the National
Day of Mourning.*

09-14-01

Rabbi Neal Rose (centre) shakes hands with Imam Hosni Azzabi, from the Manitoba Islamic Centre, after the Imam offered prayers for peace at the interfaith memorial service held in Winnipeg.

this could happen at all, fear that it could happen again and, finally, fear that it could happen here. The afternoon of the attack, the tallest building in Winnipeg was shut down. There was a terrible feeling that chaos had replaced the conventional sense of calm and ease to which we'd grown accustomed.

In that respect, there was a certain anxiety about gathering people together for a memorial at all. But I was amazed. I thought we would have four or five dozen people attending, most of whom would be the participants who were speaking. Representatives of the Jewish and Islamic faiths were present, a Mennonite choir represented the Christian community, there was an Aboriginal Elder, and then chaplains from the fire and police departments – each bringing their own message acknowledging the need to reach out and make a commitment to peace.

All in all, I think there were probably 3,000 people at the service. It was held outdoors in the plaza between the mayor's office and city hall, and the area was packed. There were people spilling out onto the street. I looked up and there were people watching from office windows and from the fourth-storey rooftops of the surrounding buildings. And all these people stood and listened for

09-14-01

Representatives of Montreal's Jewish, Muslim, Buddhist, Catholic, Orthodox and Anglican faith communities gather at St. James United Church in an ecumenical expression of faith and mourning.

nearly two hours. This was a long service, and the fact that the congregation stood and listened for that long was more amazing than anything any of us had to say. People, clearly, were looking for some sort of direction. They were looking to congregate for reassurance and strength.

The crowd came from all over. It included many Americans and other stranded travellers from all over the world. For them, especially, it was a very emotional time. People were embracing their Canadian hosts — the affection and support they received, and their gratitude in return, was very moving to see. It was a testament to fellowship and community.

Once I started thinking about what I wanted to say at the service, it seemed evident that the most important thing to do, spiritually, was to affirm. As it happened we were about to celebrate the Jewish New Year — when the world begins again. And here we were at a point when the world as we knew it had come to an end. We had all suffered a horrible loss. So I thought it was crucial to declare a renewed affirmation of the ideals we hold most precious, our most basic beliefs — about people, about the world, about justice and democracy and peace. I wanted to declare that our task in this world is to love and to build. I wanted to affirm that for each of us our holy places should be protected

09-18-01

Montrealers hold a candlelight vigil at the corner of McGill and Saint-Jacques streets.

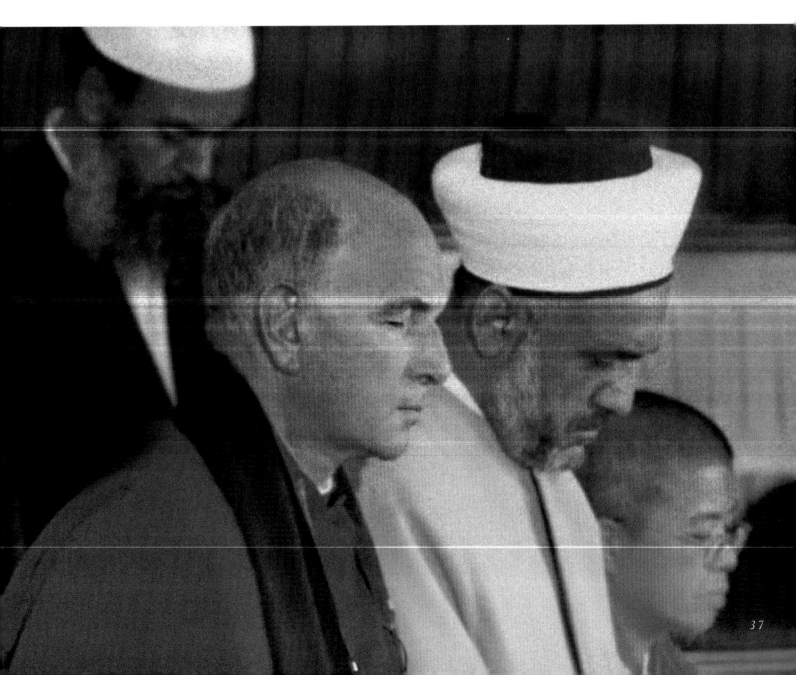

37

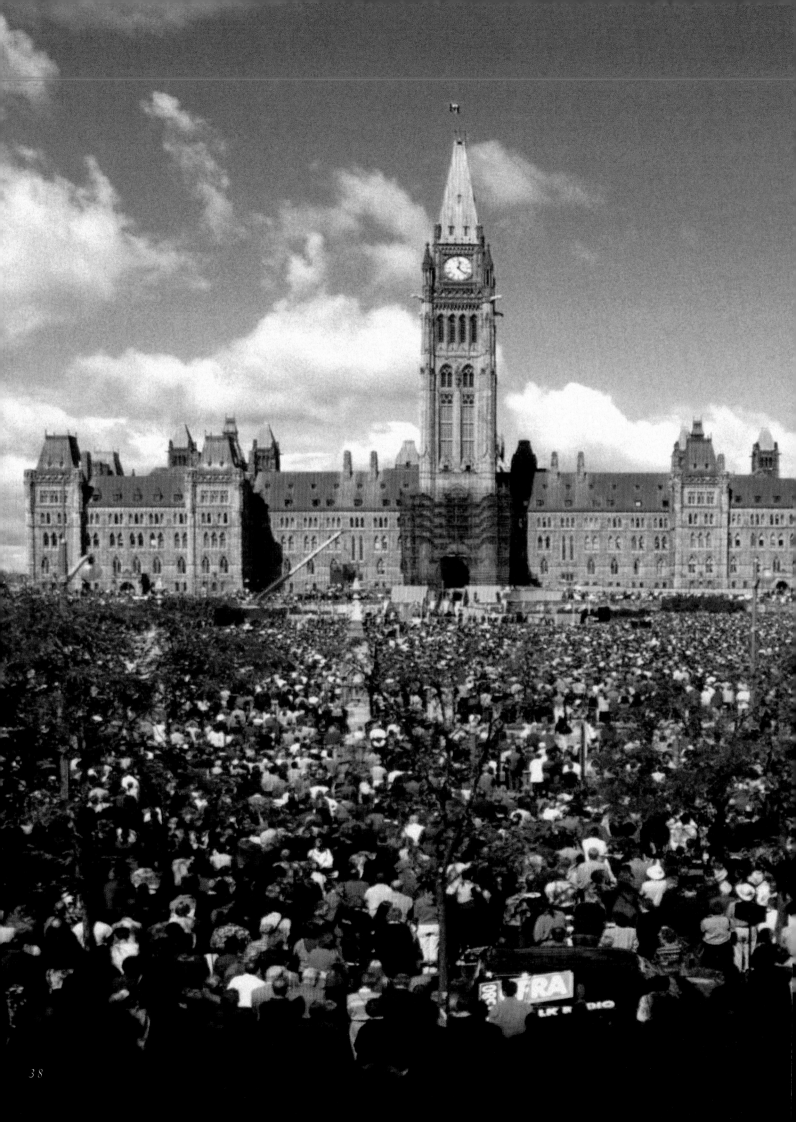

09-14-01
Canadians join in three minutes of silence during the memorial service on Parliament Hill.

and that we all have a right to our culture and traditions, as is the fundamental nature of Canadian society. I wanted to provide some hope.

In these awful circumstances, memorial services are essential because they offer structured outlets for mourning. Mourning is the language for grieving. Grieving is our inward sense of loss and disorientation, fear and apprehension. What we as North Americans mourn most, I suspect, is the terrible realization that the world is not as secure as we imagined.

Our grief was for the horror and enormity of these deaths. The death of 5,000 people within a matter of moments is unbelievably frightening. There was a tremendous feeling of loss and of being lost. We were grieving because nobody knew – and still I don't think anybody knows – what the future of this world will be." ∎

"We are gathered here to remember the victims and their families of the tragedy of September 11. Muslims offer their heartfelt condolences and sympathies. Islam is a religion of peace and justice for all people. It condemns violence and the taking of innocent lives anywhere in the world."

—Imam Hosni Azzabi, from the Manitoba Islamic Association, at the Winnipeg interfaith memorial service, delivered in French and English

"At times like these, I guard the Seven Wisdoms of life – respect, love, generosity, honesty, humility, courage and humour. These are hard laws to live by, especially in this world. And yet we must. I tell people, 'Come. Let us work together.'"

—First Nations Elder Frank Wesley, at the Winnipeg interfaith memorial service

"Today we remember those of our brothers and sisters who paid the ultimate sacrifice. They knew and willingly accepted the sacred obligation to stand watch over their neighbours as guardians against whatever disaster man or nature may direct their way. These firefighters and paramedics were among the ordinary men and women who charged forward to perform extraordinary deeds in this time of need; and whose strenuous effort and unswerving dedication united hearts and hands in service of any person in need, be it friend, foe or total stranger.

Firefighters and paramedics are uniquely bound by unifying principles, rarely spoken and nowhere written. These unspoken bonds link one to another with awesome strength and become most clearly visible when the challenge to one becomes the challenge to all. From one another we draw the strength to withstand the blow, the stamina to stand together through its impact and the courage to stand and face again, whatever risk or challenge may come.

Today we recognize that when a brother or sister of the department passes on, their spirit infuses each and every firefighter, who turns again to face the challenges that lie on the horizon.

To our family in New York and to the citizens of Winnipeg, know that at any moment in any community, wherever a firefighter lays a line, swings an axe, makes an inspection, performs CPR or educates children – in every act of bravery and in every act of compassion – the spirit and commitment of those who gave their lives shines on in the hearts and deeds of those who carry on this great calling."

—Captain Mark Young, Winnipeg Fire/Paramedic Chaplain

09-12-01

James McCallum, an exchange student at the University of Toronto, lays flowers at the city's U.S. consulate – a tribute to his twin brother, Robert, who was killed in the attack on the Pentagon.

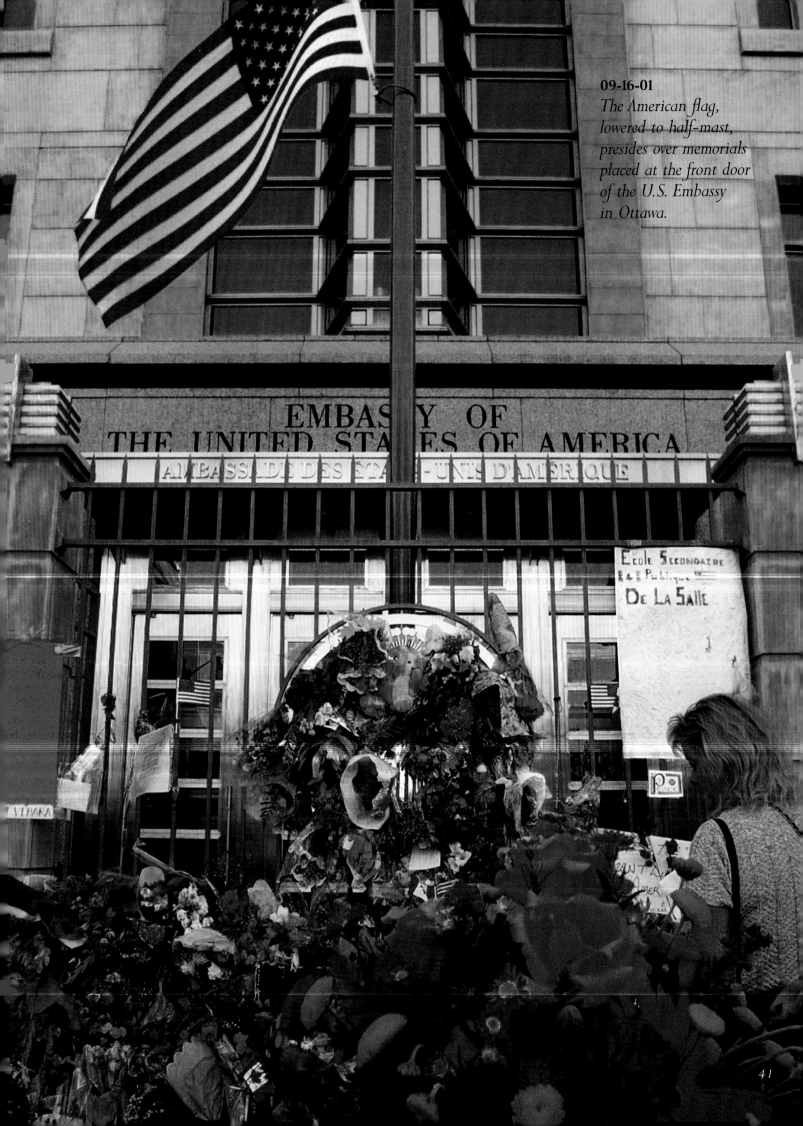

09-16-01
The American flag, lowered to half-mast, presides over memorials placed at the front door of the U.S. Embassy in Ottawa.

EMBASSY OF
THE UNITED STATES OF AMERICA
AMBASSADE DES ÉTATS-UNIS D'AMÉRIQUE

Ecole Secondaire
& Publique
De La Salle

41

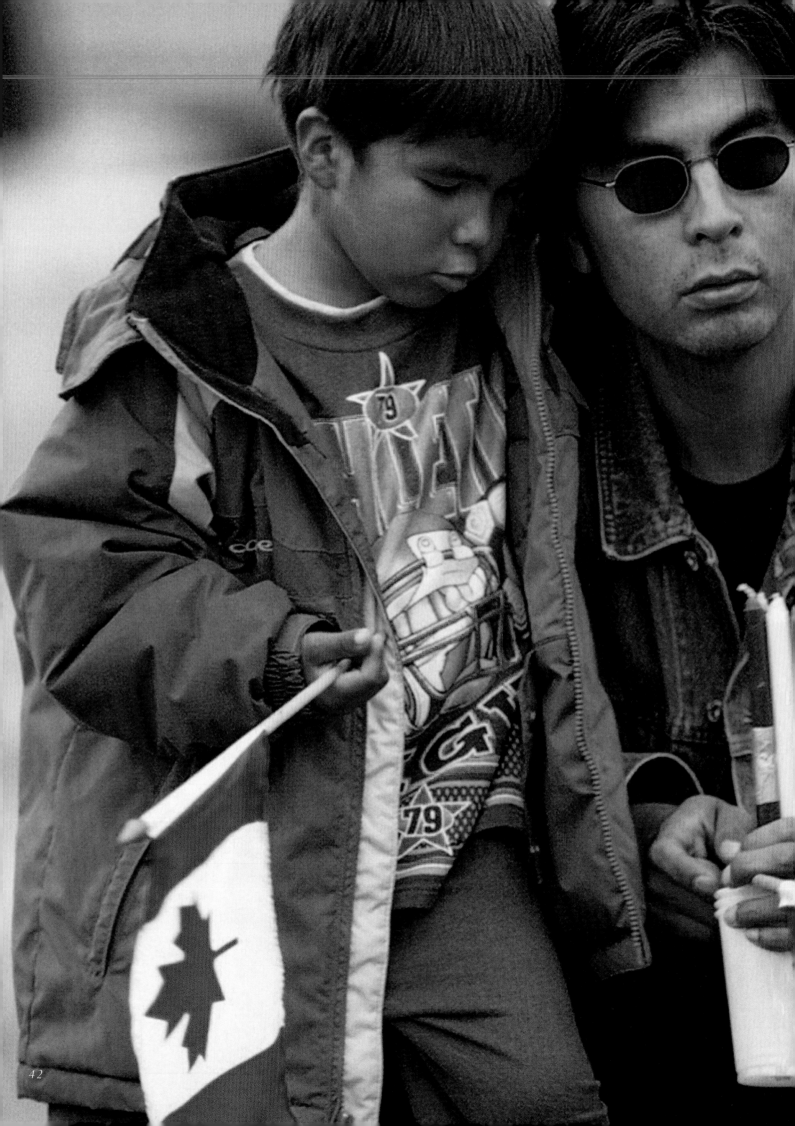

09-18-01
Marc Hunter took his six-year-old daughter and his five-year-old son to a vigil at Fire Station 1 in North Bay, Ontario.

09-14-01
Prime Minister Jean Chrétien,
Governor General Adrienne Clarkson
and U.S. Ambassador Paul Cellucci
together in Ottawa for Canada's
National Day of Mourning

44

The People of Canada
c/o The Embassy of Canada,
Washington, D.C.

"In the month that has gone by since the terrorist attacks in New York we have heard a number of stories of how Canada and its citizens have responded to the needs created by this crisis. I have just finished reading about the people of Gander, Newfoundland, and how they helped thousands of passengers stranded there on transatlantic flights.

It has been my pleasure to visit Canada on vacation [and]...the people of Canada have always been welcoming and friendly and I felt very much at home. While some U.S. citizens know little about Canada, and often take it for granted, I would like to take this opportunity to say a very large THANK YOU to Canadians for being there, and especially for being there in times of need. I would hope that if the situation is ever reversed we will be there for you.

Thanks again, GOD BLESS CANADA!"
—*Richard, Chambersburg, Pennsylvania*

"Please accept this humble effort to thank you, as a representative of all your countrymen, for your country's support of America during these difficult times.

It seems that in the confusion and tumult following the atrocities committed on September 11, 2001, Canada proved itself to be a true neighbor and real brother in time of need.

Our prayers go to God for wisdom for your leaders and protection for all your citizens from acts of terrorism."
—*Garland, Ganesvoort, New York*

"I have never felt compelled to write a government official, but then I have never witnessed anything so compelling as the outpouring of grief and the show of resolve and support from the people of your great nation.

Today I read once again the words of Prime Minister Jean Chrétien on the occasion of the National Day of Mourning in Canada, September 14, and once again I have been moved to tears.

Nothing I could say by way of thanks could be as eloquent as the Prime Minister, nor could it begin to express the depth of gratitude I feel – and no doubt all Americans feel – for his sentiments. Yet it is more difficult still to adequately thank Canada for its courageous action in response to the atrocities, which have befallen both of us. Although the gathering of your nation in defiance of evil stands as a singular act of humanity, it is the most recent display of the enduring compassion and goodness of the Canadian people.

As you have always stood with us, we will forever stand on guard for thee. We will never forget.

I have seen much recently that makes me proud to be an American.

What I have witnessed from your side of the border makes me proud to be a human being.

With profound respect,"
—*Kenneth, San Diego, California*

09-18-01

Two-year-old Nicole clutches two American flags in her tiny fist, at a memorial service held near the Canada-U.S. border south of Vancouver.

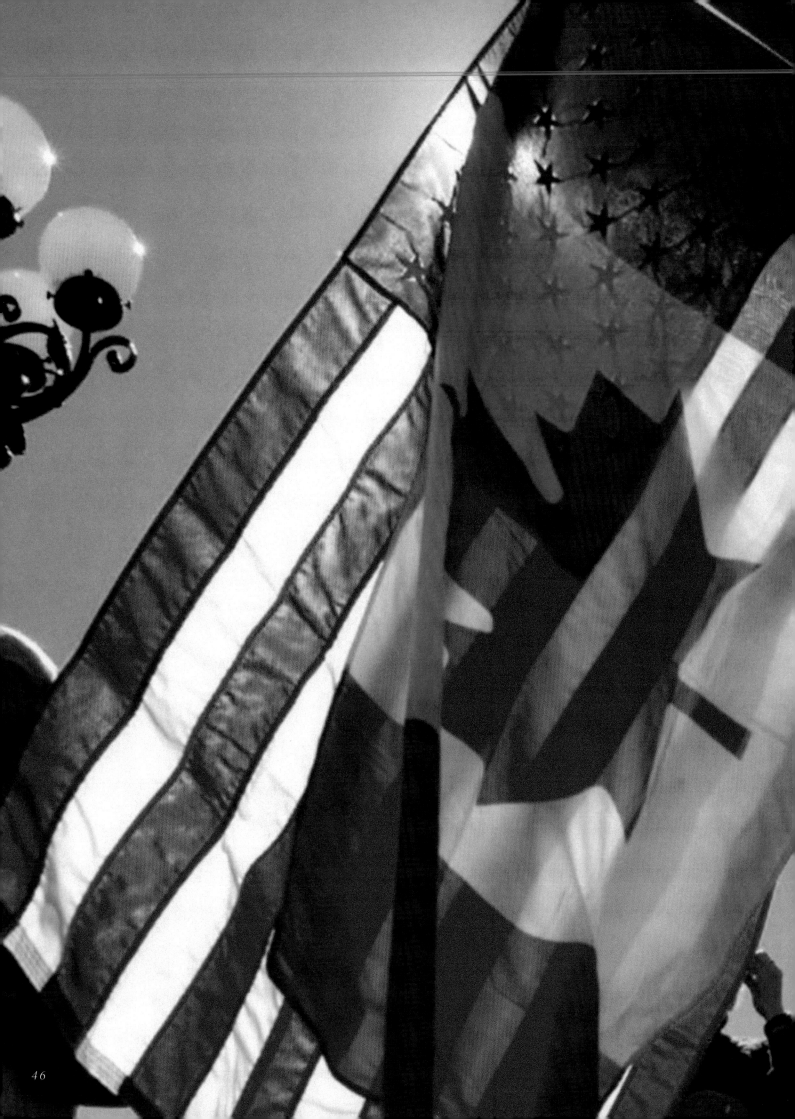

09-14-01

Richard Hodgins shoulders both the Canadian and American flags, creating an image of unity beneath a clear Ottawa sky.

TO ALL N.Y. FIREFIGHTERS
FAMILIES OF THE FALLEN
BROTHERS AND SISTERS
...'M SORRY FOR YOUR

"YOU RUSHED IN SO
OTHERS COULD R
(UT

OUR HEARTS

09-14-01

The coat of retired fireman Butch Moore hangs on the U.S. Embassy fence in Ottawa. His message: "To all N.Y. firefighters and families of the fallen brothers and sisters, I'm sorry for your loss. You rushed in so others could rush out."

Art Viens, sergeant-at-arms of Maple Ridge's Royal Canadian Legion Branch 88, led a procession across the Canada-U.S. border for the Hands Across the Border memorial in Sumas, Washington.

"I GAVE THE COMMAND and, led by a bagpiper, we marched six-abreast across the border to the United States. The colour party carried the Canadian and American flags. And then, behind the Honour Guard, were B.C. firefighters, ambulance and police.

The ceremony was a memorial for those who died. We had to get special permission from customs officials in Washington to open up the border and allow us to march through. It became a double memorial, though, when our chief of police died in the line of duty the day before.

As we marched across, the traffic was stopped on either side. There were a lot of vehicles and the drivers quietly waited, they didn't seem to mind. A lot of them parked their vehicle for a while to watch the ceremony, which lasted for nearly an hour and ended with our return, marching back over the border.

We were met on the American side by the fire and police departments of Sumas. Together we sang the American anthem. The flags were dipped. I found it all very touching.

One of the speakers was particularly moving. She was the acting mayor from Abbotsford, British Columbia. Her husband is a fireman and they have a young daughter. The mayor told us about her daughter, who has been watching the horrible events of recent days as they unfold on the television. One night the young girl said to her father, 'Dad, you see that? That's why you shouldn't be a fireman.' He replied to his daughter, 'No. That's why I am a fireman. To save lives.'" ∎

10-04-01

A Massachusetts businessman who spent two days stranded in Halifax, Nova Scotia, placed a billboard to express his gratitude for the city's hospitality (top).

09-19-01

Retired fire captain Brian Hawkins, wearing dress colours, walks in a procession of firefighters at a memorial service in Edmonton, Alberta (bottom).

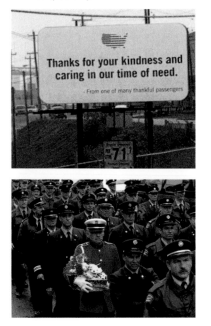

A Diary *Between Friends*

09-18-01

Art Viens, sergeant-at-arms with Maple Ridge's Royal Canadian Legion Honour Guard, wipes away a tear during the American national anthem at the border memorial in Sumas, Washington.

Tears run down Nancy DiNovo's cheek as she plays at a memorial service in Christ Church Cathedral in Vancouver, British Columbia.

09-14-01

Three Calgary firefighters salute with the American flag hanging from the bucket of their aerial ladder during an interfaith prayer service.

53

09-14-01
*Virginia Canil, wife of the
American consul general
in Winnipeg, Manitoba,
weeps at the conclusion of
the city's memorial ceremony.*

09-11-01
*Students from high
schools across Windsor-Essex
County, Ontario, stand in
the rain at an interfaith
candlelight vigil.*

"There is no border between our two countries at a time like this."

"I can't stop crying"
—Lisa, Ladner, British Columbia

"I watched firefighters
define the word hero.
I watched police officers
define the word protect.
I watched a mayor
define the word responsibility.
I watched a president
define the word courage.
I watched American people
define the word dignity.
I watched a world
define the word compassion."
—Jo-Anna, Maple Ridge,
 British Columbia

"There is no border between our two countries at a time like this."
—Larry, Squamish, British Columbia

"America is our family,
America is our friend and
America is our neighbour.
America's sorrow is our sorrow and
America's tears are also our tears.
We stand beside America
and shall never abandon her."
—J.R., Terrace, British Columbia

"I think I speak for all of us when I say that the world is crying for you and we all wish we could take away this horrible hurt."
—Shauna, Richmond, British Columbia

09-24-01
A western approach to fundraising finds 70 Albertans on horseback for a six-day, 200-kilometre journey to Montana. They were met at the border by a group of Montanans, also on horseback, and presented them with $35,000 from their saddlebags.

"To watch and listen to people's stories over the last few days made me pull my own family closer. To watch your fellow Americans rise up and begin to fight this unseen enemy made me proud to be your neighbour."
—*Jennifer, Duncan, British Columbia*

"We, as Canadian North Americans, share our deepest sorrow and feel so very proud to be your close neighbours and allies.

It is our intention to fly the American flag alongside our Canadian flag in front of our home to show solidarity and support for the difficult days ahead in fighting this new war on terrorism.

May God bless you all."
—*David and Joan, Sechelt, British Columbia*

"We are deeply saddened by last week's acts of terrorism. We are very sorry that all of the people have died. Your sorrow is our sorrow, too. We hope that our love will comfort you. We will always be there for you. We also drew pictures to support everyone in the United States."
—*Students of Division 15, Grade 2, James Hill Elementary School, Langley, British Columbia*

"Please know you do not stand alone, you do not cry alone and you will not fight alone."
—*Susan and Misty, Surrey, British Columbia*

10-03-01
Volunteer Annette Veira (top) serves one of 231 apple pies to NYPD officers at Ground Zero. The pies were baked by Canadians and delivered in boxes decorated by Canadian schoolchildren (bottom).

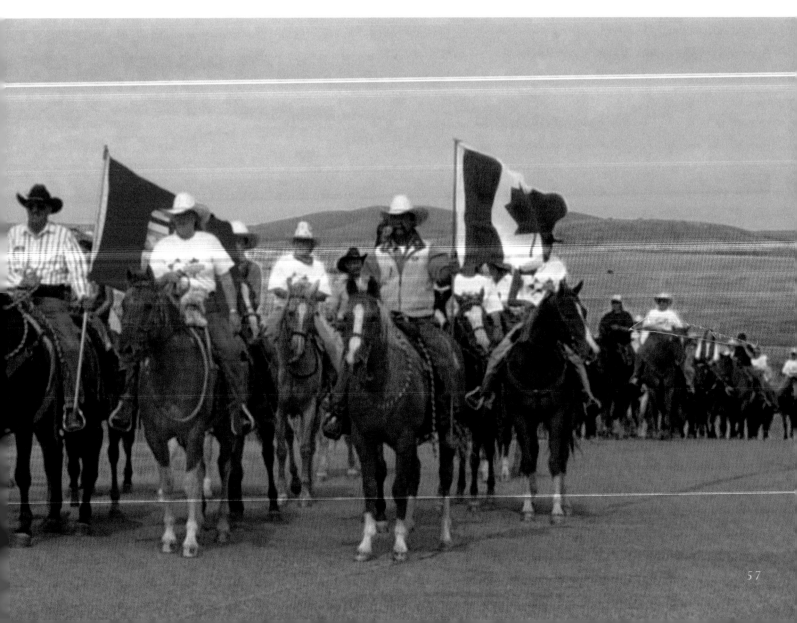

*"We saw the worst
of mankind in these
acts, and the best
of mankind in the
heroes who risked
their lives to help."*

09-12-01

*A woman reflects among a crowd
of 4,000 at a memorial service
in London, Ontario.*

09-14-01
A man is overcome with emotion at an ecumenical service at St. James United Church in Montreal, Quebec.

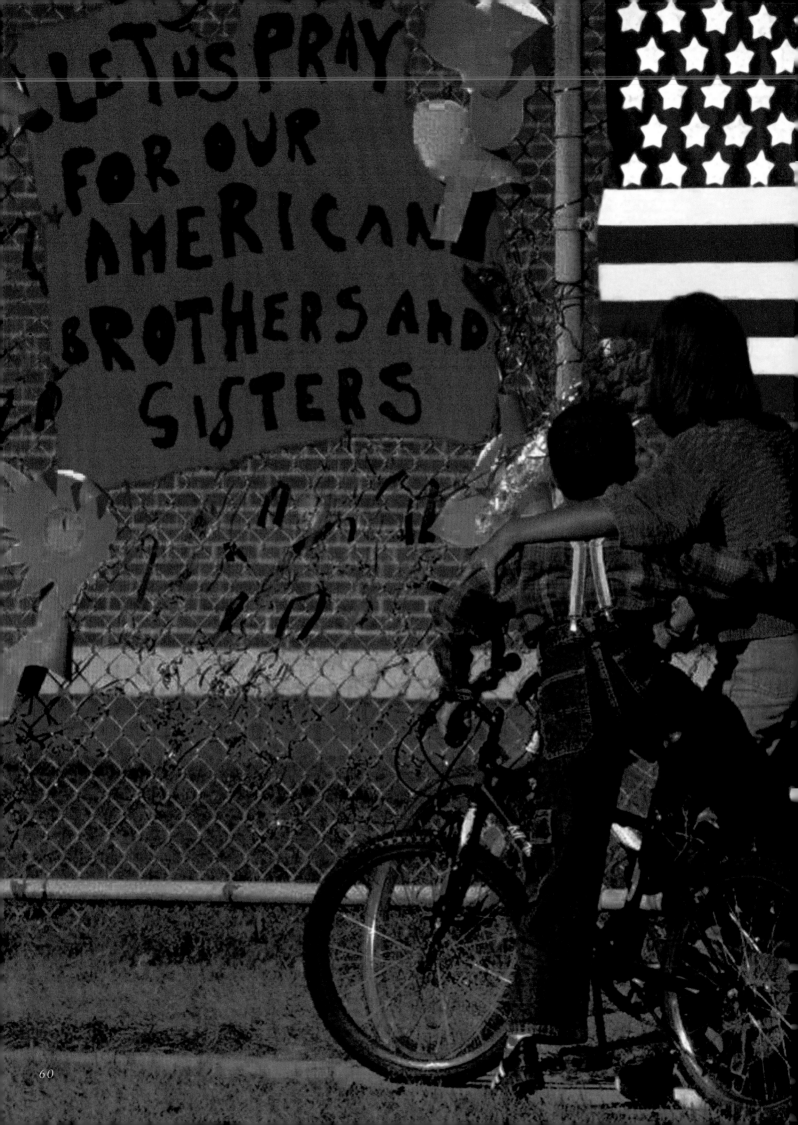

09-19-01
A hand-painted sign of support hangs outside
St. Catherine Catholic School in Toronto, Ontario.

09-19-01
Jim Ferney, a teacher at Ryerson
Public School in Cambridge,
Ontario, directs 170 students and
teachers to spell the word "peace"
in the school parking lot.

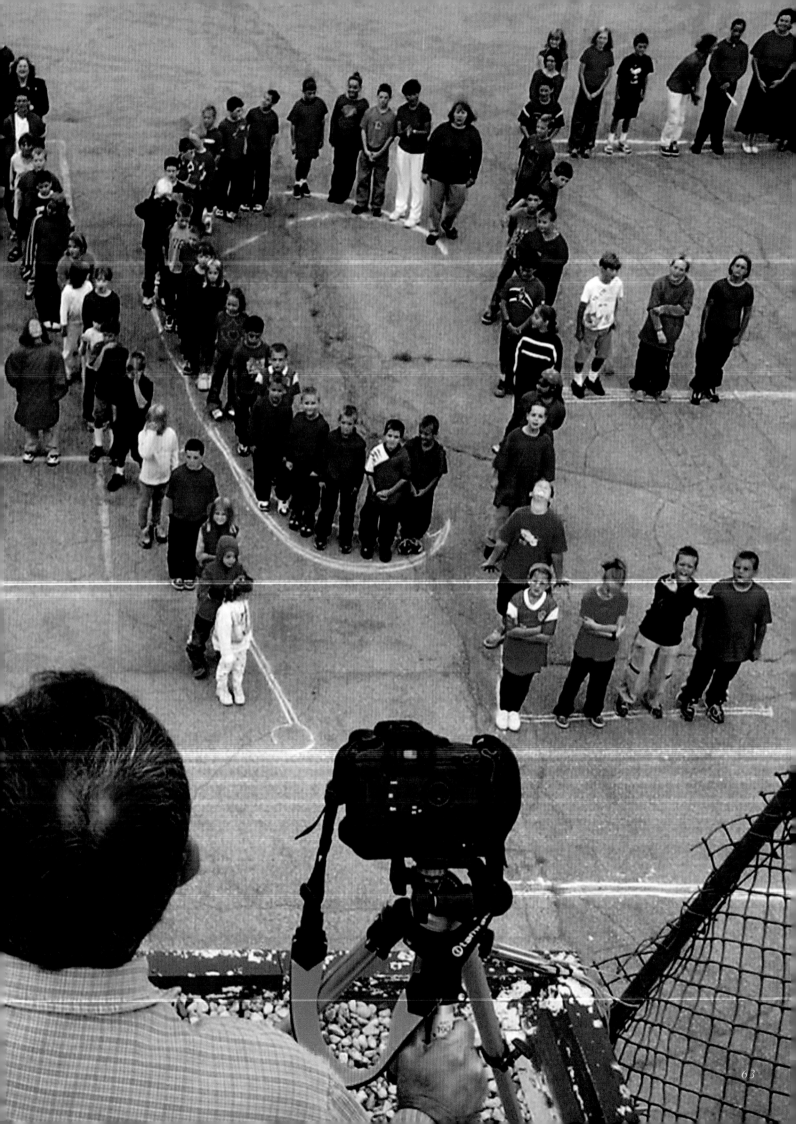

"Make no mistake,

we, like you, stand

for freedom and

will do anything

we can to protect it."

09-19-01

Grade 6 students from St. Clement's School in Kitchener-Waterloo, Ontario, weave peace bracelets for sale as part of a fundraising drive for relief efforts in New York (top).

09-26-01

"Love your Neighbour" is the message on T-shirts being sold by Grade 5 and 6 students at St. Edmund's Elementary School in North Vancouver, British Columbia (bottom).

Letters sent by Grade 8 students at Dundas District School, Dundas, Ontario, to a New York school, to express their feelings.

REAL MEANING

"Peace, love, and brotherhood
Three words that mean so much
For peace there's doves,
For love there's hearts,
For brotherhood there's hands adjoined.
But real meaning is,
For all there above
Not a symbol or a picture
It's the way we feel
For those in need,
The way we feel right now."
—Kate

REFLECTIONS

"It's hard to believe what happened today
Yet easy to feel the pain,
The pain of all the families who have lost
And nobody who has gained.
Whose mind is so unfair and cruel?
Whose could do such a thing?
We do not know we can only blame,
And reflect in horror and shame.
We cannot bring back anyone,
We cannot see them again
Thousands of innocent people
Lost and nothing gained
The attack has brought insecurity
To humanity as a whole
Who is the person responsible?
Does he really have a soul?
So when we go to bed at night
Will we sleep in peace?
Is this mourning over?
When will it ever cease?"
—Rachel

WHAT IS IT ALL ABOUT?

"As American society was left in doubt,
People wondered what it was all about.
For those who were brave and took the test
To help the victims and all the rest.
The towers of dust are now grounded.
But by the memories, we are still hounded.
Now citizens from every land
Come to give a helping hand.
In these days of fear and doubt
We wonder what it's all about."
—Martin and Kenny

Letters sent by Grade 7 students at Blind River Public School, Blind River, Ontario, to New York rescue workers.

"Dear Rescue Worker:
THANK YOU!
Thank you so very much for everything you have done. Thank you for searching through the rubble for survivors. Thank you for caring enough to devote your time. YOU WILL ALWAYS BE MY HERO!"
—Dylaina, 11 years old

"Dear Rescue Worker:
This letter may not help you much
After searching through the debris and dust
The tragedies you came upon
I'm sure you'd feel better just resting
on your lawn
We know you're working as best you can
And of them all I am your fan.
We know your job
is extremely hard,
So that's why I wrote this
appreciation card."
—Mitchell

A Diary *Between Friends*

09-15-01

Seven-year-old Rebecca and her four-year-old brother Jamie set up a fruit stand and sold pears from the family tree by the roadside in Windsor, Ontario. They raised $59.06.

09-13-01
Kindergarten pupils Dontai (left) and Christopher with drawings by their classmates at Coronation Elementary School in Montreal, Quebec.

"My dad is a firefighter, and I cannot imagine what it would be like for the children of New York's firefighters not to have their fathers come home."
—Joel, Bayridge Elementary School, Surrey, British Columbia

"I think these attacks were to shock and demoralize the American people and to make us all feel helpless and vulnerable.

What it did was the opposite. We saw the worst of mankind in these acts, and the best of mankind in the heroes who risked their lives to help."
—Lawrie, Maple Ridge, British Columbia

"I will not pretend I am not without fear, for my children, my family and my friends, but I do go on believing that there is more good than bad in this world."
—Denise, Coquitlam, British Columbia

"To all the victims and their families of September 11, 2001's horrific tragedies:

I have not known you, but indeed I will never forget you. I pray daily for healing for all of us."
—Laurie, Abbotsford, British Columbia

"I have never seen so many American flags outside of the continental U.S. ever before. I am proud of my fellow Canadians and everything we stand for. Make no mistake, we, like you, stand for freedom and will do anything we can to protect it."
—Angela, Courtenay, British Columbia

"THANK YOU! You made twice as much help these days!

Thank you Canada for all your help. You let us take our planes to your country. You took your fire truck and police cars to help. You gave the plane passengers food and rooms too. The point is THANK YOU CANADA!"
—Alex

"THANK YOU CANADA!!
Dear Canadian neighbors,
From one peace-loving nation to another, thank you for helping us in a time of crisis. It's like getting locked out of your house, and knowing you can go next door for help. The U.S. and all her neighbors must stick together to put a stop to terrorism."
—Sara, South Forsyth Middle School, Cumming, Georgia

"Dear Canada,
Thank you for helping so much. We will repay you some how, some day. We salute you for being so kind and helping us in this time of tragedy. We will remember the nice thing you did for us forever."
—Christian

"BEST OF FRIENDS!
Dear Canada,
I'm in Mrs. Knorr-Kolkkas 6th grade class at South Forsyth Middle School. I just wanted to take time to thank you for what you did for our country! It was very generous for you to take the planes that were flying into the U.S. to your airport, giving them a place to stay and give them food.

I don't know how to thank you enough!"
—Kristina, Cumming, Georgia

09-21-01
A young artist from James Hill Elementary School in Langley, British Columbia, makes a simple yet powerful statement.

09-20-01
A "Dear Canada" card, sent by schoolchildren from Georgia to the Canadian Embassy in Washington, contains the greeting: 'Thank you for helping so much. We will repay you some how, some day. We salute you for being so kind and helping us in this time of tragedy.'

09-18-01

Toronto Maple Leafs and Montreal Canadiens put the competitive spirit aside and stand united on the ice for a moment of silence.

STRENGTH. CA

09-13-01
*At the U.S. Consulate
in Toronto, Ontario, a
sidewalk artist leaves a
message of encouragement
for the bereaved.*

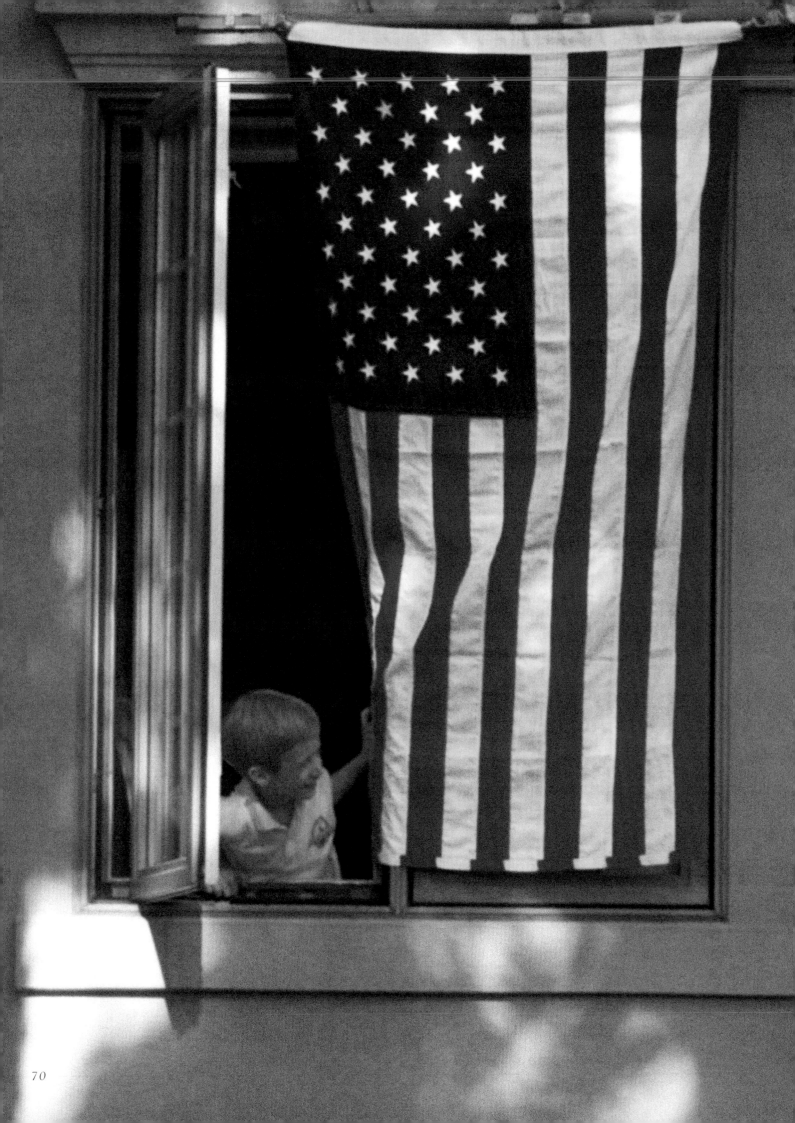

09-17-01

Toronto windows draped with Canadian and American flags are occupied by five-year-old Clark, left, and his sister Helena, together with friend Katie, both eight years old.

09-17-01

Calgary Police Association president Sergeant Al Koening displays a ribbon bearing the likenesses of a firefighter and a police officer. Funds from the sale of the ribbons are being donated to the Patrolmen's Benevolent Association in New York.

09-17-01
Winnipeg Blue Bomber and proud American Brian Clark is overcome by emotion as his national anthem is sung in tribute before a Canadian Football League game in Winnipeg, Manitoba.

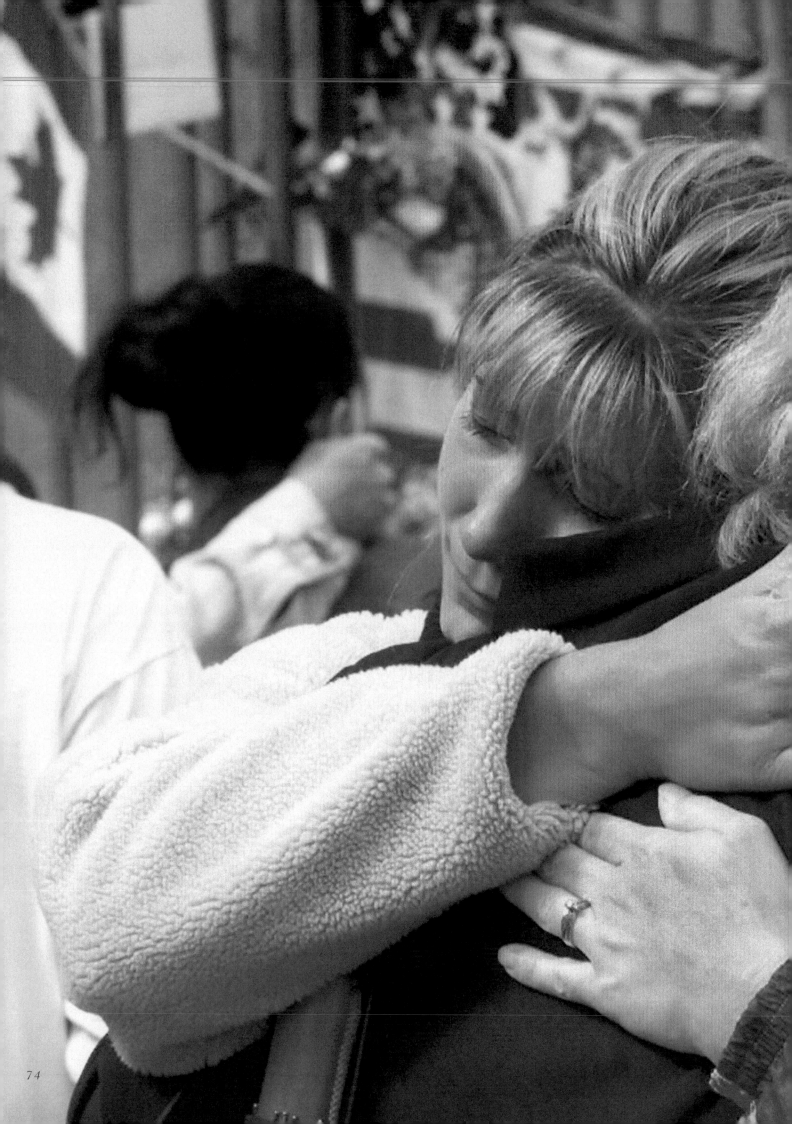

09-14-01
*An emotional embrace at
Christ Church Cathedral's
memorial service in
Vancouver, British Columbia.*

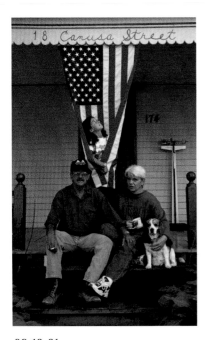

08-19-01

Patricia and Milton Willis, American residents of the border street shared by Newport, Vermont, and Stanstead, Quebec, proudly display their patriotism.

Patricia and Milton Willis live on the south side of Canusa Street in Newport, Vermont. On the north side is Stanstead, Quebec. The Canada-U.S. border runs straight down the middle.

"WE KNOW OUR CANADIAN NEIGHBORS are with us. We look across the street and see the American flag flying. On the Canadian side they held a ceremony at the border stone, decorating it with flowers and flags. We've always lived on a friendly border here, even more so now.

I've lived in this border town all my life. My mother's parents came from Rimouski, Quebec. My father's father built the house we are living in now. And my husband's family came from Mansonville, Quebec. They came over here to live 100 years ago when they drew the border. I guess I wasn't expecting Canada's fervent support after the 11th. And then I had to ask myself, Would I go to the trouble, if something happened to Canada? Would I go to the trouble of flying their flag? Yes, I think I would. But it's not a question you ask yourself unless it happens.

Canada and the United States of America are unified in many ways. Obviously we know that Canada is in fact a separate country, but we don't think of it that way. We freely walk back and forth across the street, and so far that hasn't changed. We don't have a sidewalk on our side and we've always been free to use the sidewalk on the Canadian side. The custom guards know us and just give us a wave.

On September 11, my husband being a veteran and our family being patriots, we felt violated by the attacks, as did Canada. I think the United States is grateful for Canada's speaking up and letting us know that they are there for us. I have more respect for Canada now, and I think the whole of the U.S. does as well." ∎

Madelaine Cronin and her husband, Gerald, live on the other side of Canusa Street, in Stanstead, Quebec, right across the road from the Willises.

"HERE ON CANUSA STREET, our neighbours across the street are American, and in light of the 11th they're demonstrating their patriotism more than usual. Flags are popping up everywhere. And in sympathy, many people on the Canadian side are buying American flags and putting them out. We're sticking them on our lawn and cars. And driving around the city, when anyone spots one, whether a Canadian sees an American or vice versa, there's honking and waving, a short little communication saying, 'Hey, we support you.'

Because I have dual citizenship, I have a hard time thinking of the Canada-U.S. border as a divide. We don't think of it so much as another country across the road just because of a line. My parents are French-Canadian, but when I was born, back then, the closest hospital was across the border in Newport, Vermont. My husband's son is also a dual citizen. As an American he could be called off to war. But I think being dual is a very good thing for us. I think it's very rich to have the two together. It's like having the two languages, English and French.

I was watching a television show the other week that suggested that, in the aftermath of September 11, divorces are being cancelled, people are getting closer to each other, more couples are planning weddings. I think it will change people more that way. It might also solidify the bond, forge a stronger link, between the two countries. A lot of Canadians feel more connected to the Americans as allies now. And I think the Americans have a better idea of who Canadians are as well. Sometimes it takes hardship to appreciate what you have around you." ∎

10-22-01
Vanessa Marshak, who works for a coffee company in Whitehorse, Yukon, makes preparations to send 45 kilograms of coffee a month for six months to the workers at Ground Zero.

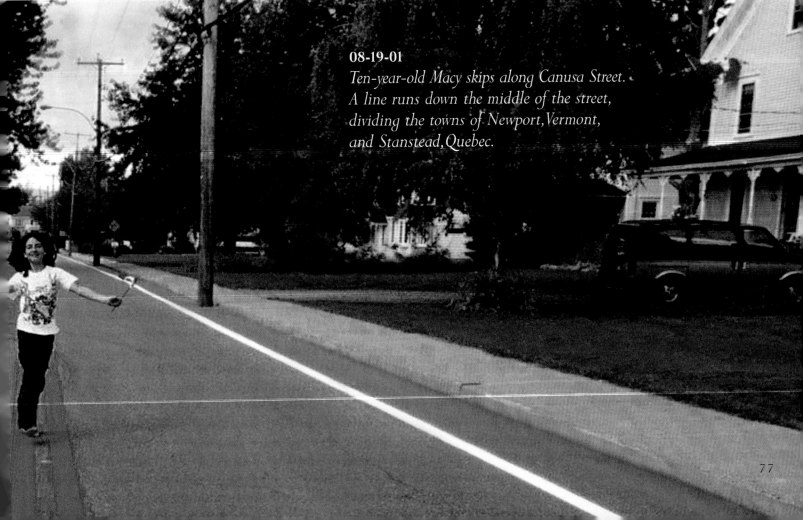

08-19-01
Ten-year-old Macy skips along Canusa Street. A line runs down the middle of the street, dividing the towns of Newport, Vermont, and Stanstead, Quebec.

10-21-01
Alanis Morissette performs at the sold-out Music Without Borders fundraising concert held in Toronto, Ontario.

09-28-01
Céline Dion returns to the stage from a two-year hiatus for a Red Cross benefit concert in Montreal, Quebec.

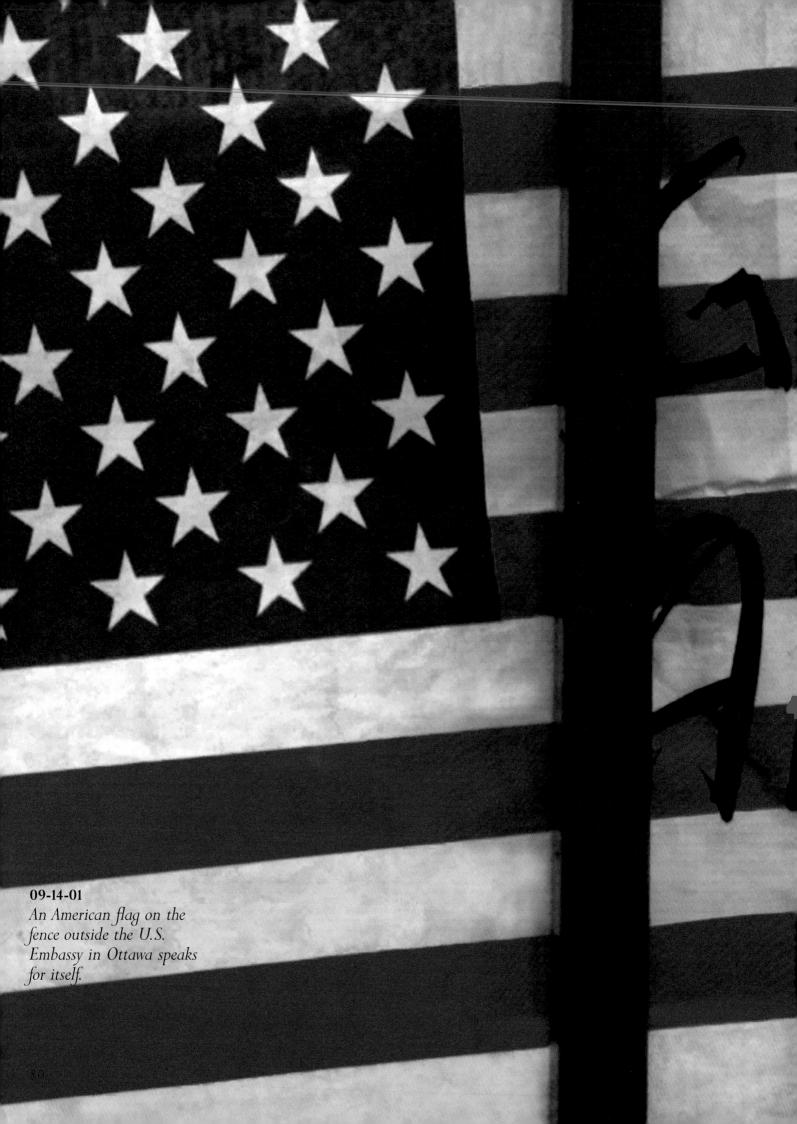

09-14-01

An American flag on the fence outside the U.S. Embassy in Ottawa speaks for itself.

09-13-01
*Mohawk steelworkers
at Ground Zero, amid
fragments of the building
that their uncles and
grandfathers had helped erect.
Photograph by Kyle Beauvais,
Kahnawake, Quebec.*

Going to Ground Zero

Jeff Boyle, a firefighter with No. 5 Firehall in Champlain Heights, Vancouver, British Columbia, travelled to New York City to be with his longtime friend, Zeke Quin, a firefighter with the New York Fire Department. The visiting convoy of 51 Vancouver firefighters also presented a cheque for $600,000.

"I DIDN'T GET THROUGH TO ZEKE until two days later. Right away when I heard I started calling him, trying to get through to New York. We've been friends for 17 years – we met at the World Fire-Police Games in 1985 and kept in touch ever since. Later on, he came up to Canada for his honeymoon.

I kept trying and trying him the day it happened. The 718 exchange for Staten Island was clogged up. It was that sick feeling – not being able to get a hold of him, wondering if he was safe or not,

thinking of the possibilities, waiting and wondering and trying and trying and trying to get through.

I got to work in Vancouver that morning at six o'clock, so I heard it on the radio as it was happening, just as I was driving up to the firehall. We sat in front of the TV there and watched it all day. We just sat and watched. I was wondering what the guys down there were thinking and going through, running back in and trying to dig those guys out. I could just imagine the pass alarms going off all over the place – firefighters all have an alarm on the air tank they carry over their back, and if you are still and don't move for a certain amount of time, say 30 seconds, it starts to go off with a very high-pitched squeal so you know there are guys down. I knew it would be chaos. People running out and firemen running in, as usual.

10-25-01

Shawn Dighton sleeps en route to New York City after fighting a fire in Vancouver the night before.

"I just wanted to know that he was fine. I said, 'Give him my love and tell him I'm coming as soon as I can.'"

09-16-01
*Brampton Ontario
firefighters Neil Kennedy
(left) and Scott Walker
— in New York to help
with the rescue effort —
offer a local boy a low-five.*

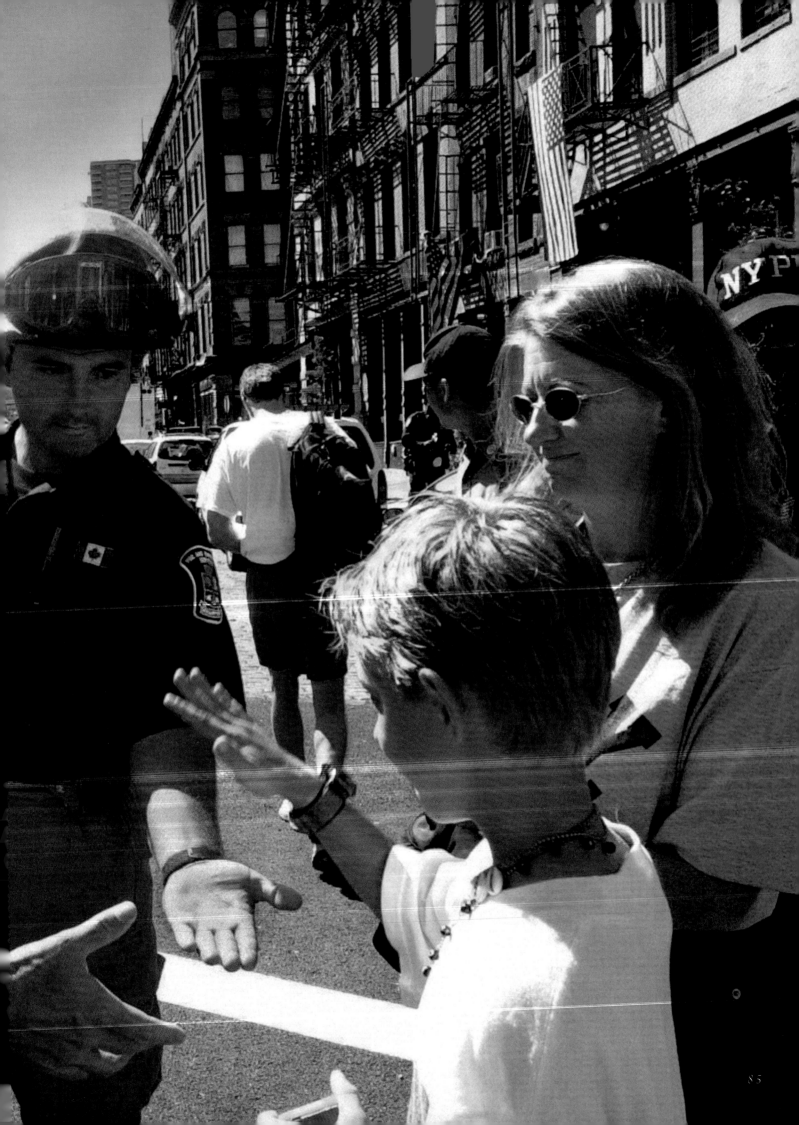

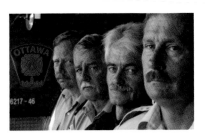

09-21-01

Ottawa firefighters Gordon Thorpe (left), Brian Foley, John Hamilton and Steve Carmichael used their vacation days to contribute to the rescue effort.

But that's our job. That's what we do. And I know they'd do it again.

All day, I didn't know whether he was at work or not. When I finally did get through, I talked to Zeke's wife, Nancy. I just wanted to find out if he was all right. She said, 'Yes, he is fine. His brothers are fine.' But, she says, Zeke has lost many, many friends. She was very upset. I didn't keep her on the phone long, I just wanted to know that he was fine. I said, 'Give him my love and tell him I'm coming as soon as I can.'

I found out later he had indeed been working that day. He works on Staten Island, and he was in the second wave of units that were called into the city, to the pit, as they call it. He was fortunate enough not to be there when the buildings came down. From what he told me, they had rerouted his rig, otherwise he would have been there. They were coming into the city and were going to go under one of the tunnels that come up right at the World Trade Center, but they couldn't get through. So they were detoured and came around about five minutes after the second tower came down. He would have been there on site if that tunnel had been open. Fate. You can only put it down to fate.

Almost immediately, we got permission from our fire chief to do a one-day fundraising blitz while on duty. The chief said, 'Okay, all the fire trucks in the city are going out into their respective districts shaking the boot.' It ended up there were about 150 guys out on duty with their rigs at shopping malls and places like that. And I think we had as many as 400 guys come in on their own time and grab their boots and man different areas, even the middle of the street. People were literally

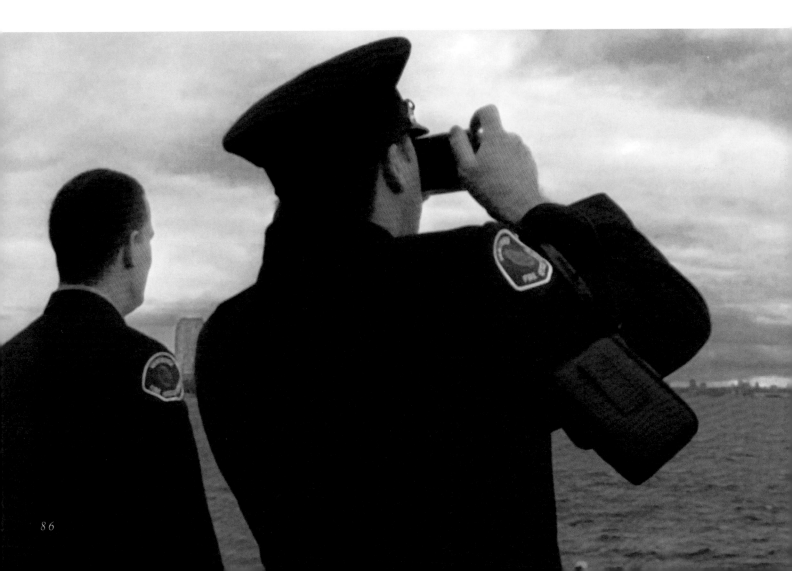

throwing money at us. It was insane! Nobody expected that. We thought we could raise maybe $100,000 in the 12 hours, seven in the morning 'til seven that night. When the numbers started coming back we knew it was higher than 100, but we didn't know what. The cheque was for $600,000. Now it's over $650,000. People are still giving us money. We are just floored by the generosity of the people of this city. We had little kids giving us plastic bags full of pennies. So you know they are emptying out their piggy banks. And people were coming up and giving us their condolences, saying they are sorry that we lost so many of our brothers.

After the fundraiser, we went down for a week in October. There were many, many tears when we presented the cheque. When Zeke got up there and mentioned my name, I was nearly gone. He said the firemen of Vancouver are so good to him, one in particular that he met 17 years ago and spent his honeymoon with. I really just about lost it.

Zeke's lost many good friends. It's killing him. There are a lot of demons. It's going to take years, probably a lifetime, to deal with. The emotions range from disbelief to anger. In a lifetime, a fireman might lose one friend at a fire. But to lose the better part of 400 men in the span of an hour is incomprehensible. To lose friends like that and to lose whole crews, it's just devastating. And there's a big family thing, there are lots of brothers and fathers working together in the department in New York. And to be a firefighter anywhere is to belong to the brotherhood. There is definitely a strong bond. Seeing that many go in New York, it hurt a lot up here." ■

09-13-01

Rescue dog Barkley and canine search specialist Flynn Lamont prepare to leave Vancouver for New York City.

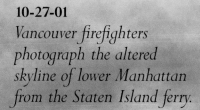

10-27-01

Vancouver firefighters photograph the altered skyline of lower Manhattan from the Staten Island ferry.

> *"A lot of the firefighters who came to New York were guys I'd never met before, but right away they seemed like old friends."*

Zeke Quin is a firefighter on Staten Island with Ladder 83.

"I WAS CRYING when we had the fundraiser ceremony at the Canadian Consulate in Manhattan. I'd never been to an embassy before, and they treated us so well and made us feel so at home. We got a few people up there speaking, and, for me, it's hard to get through anything without becoming pretty emotional. And these Canadian guys, they were right there with us. They feel like I do. That says a lot, especially considering they're so far away. But somebody was saying the other day, we're really grateful but the money was secondary. It's the thought that counts, that the Vancouver people went out of their way to do that. It helps a lot knowing there are people out there who care. That's proof that the people of the world unite when terrible things happen.

It was beautiful to see them when they got here. The first batch came, and then Jeff came with the second batch. And more are coming still. There are 70 guys coming next week. A lot of them were guys I'd never met before, but right away they seemed like old friends. It was unbelievable to have that kind of support. It really lifted my spirits. I took them around to different firehouses. And, you know, you could sense the camaraderie, even though we are from different countries.

They wanted to bring their bunker gear down and work in the site. But things are so confusing and complicated down here that it's not as simple as that. I think a few guys did do some work on the spur of the moment. But it's day-to-day. We've got a million and one things going on right now. We're crazy here. We go out in the morning for a funeral, and tonight

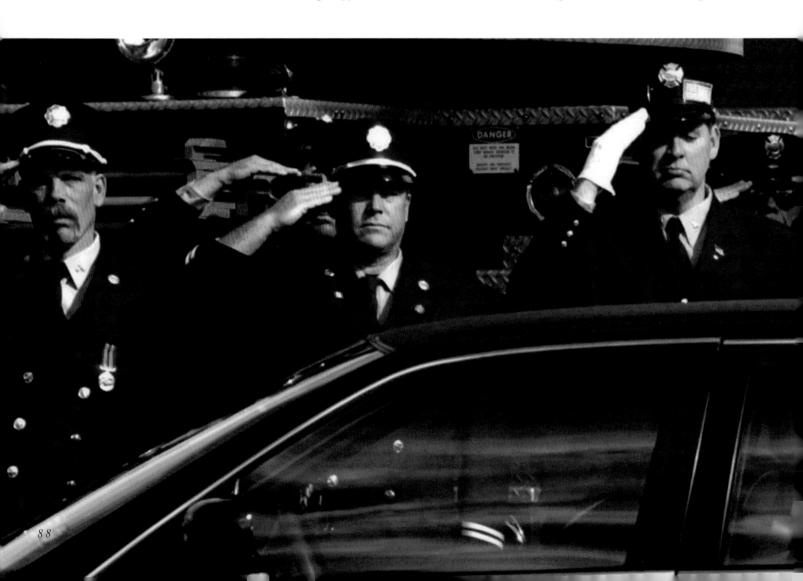

we have a wake – we actually get everyone together and take the fire rig. And we're cooking for families. We're trying to get back to normal, but there is such a long road to travel. It's heart-wrenching and it's going to last for a long, long time. Just seeing families that you know well being torn apart by this is the hardest part. And in light of that, it means so much that the Vancouver guys are here. This past Saturday was the memorial service for my dear friend Lt. Joe Gullickson of Ladder 101 in Brooklyn. Over 60 Vancouver firefighters made it a point to be there. It meant so much to me and to Joe's wife Naoemi. We've been to so many funerals... moral support is the most important thing.

The bonding is what I like best about the job. And helping people, there is nothing better than that. We searched for bodies all that first day, with not much luck. And if I'd have gotten there a few minutes earlier, I would've been dead. When I first got there I was so busy and wrapped up in doing my job I didn't have time to think about what exactly was going on. But after a little while, when I saw all the smoke come up out of the building, I started talking to God. I said, 'If this is the end of the world, You can take me. I'm ready.' I was ready to go to heaven. But it wasn't the end of the world. We must carry on. My friendship with Jeff is stronger than ever. And I made new friends. And my friends in New York – there are a lot of people in New York that I know really didn't pay any mind to the Canadian-American relationship before. It was an understood thing – now, with the Vancouver guys coming down here and meeting a lot of my friends, so many of them are telling me what great people Canadians are. Which, of course, I already knew." ∎

10-26-01
Vancouver firefighter Wayne Humphrey despairs after visiting Ground Zero, also known as The Pile (top).

10-27-01
Rod McDonald from the Vancouver fire department consoles New York firefighter Zeke Quin, after delivering a relief cheque for $600,000.

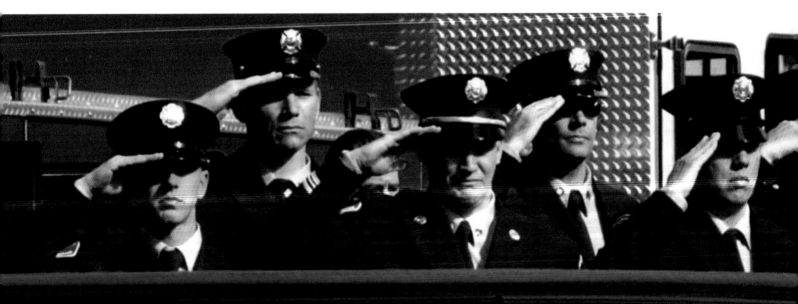

10-27-01
New York and Vancouver firefighters together salute the hearse of firefighter Michael Fiore during his funeral on Staten Island.

09-16-01

New York student Rachel Allen gives Brampton firefighter Neil Kennedy a hug, after he and three colleagues drove to New York to help for four days.

09-29-01
Prime Minister Jean Chrétien
gazes at the devastation
at Ground Zero.

10-20-01
Battery Park in New York City
is the site of a candlelight
vigil held by a Canadian
tour group.

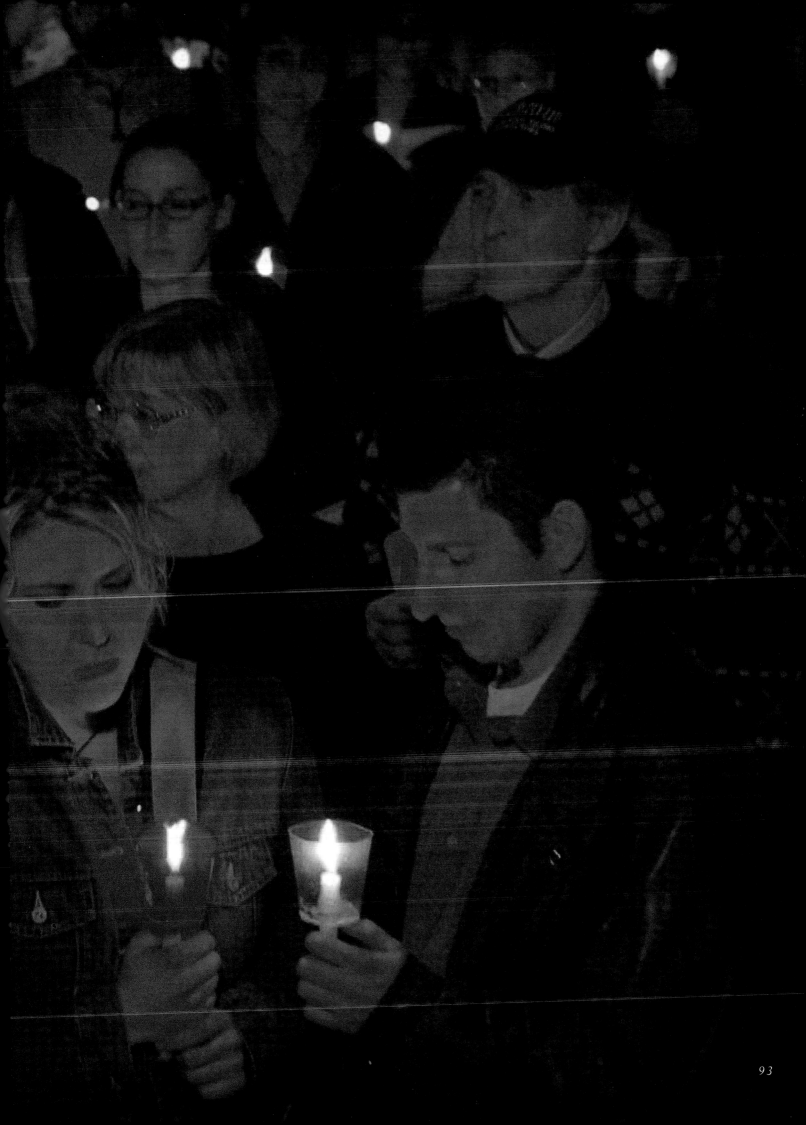

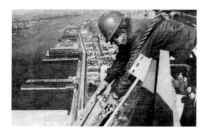

Circa 1970

During the construction of the World Trade Center, steelworker Walter Beauvais (above) worked as foreman of a crane gang. His nephew, Kyle Beauvais, has been at Ground Zero clearing away the remains of the towers and sending them to the scrapyard.

Kyle Beauvais is a steelworker from the Mohawk Nation in Kahnawake, Quebec. He has been helping with the Ground Zero recovery effort in New York since September 11. His Uncle Walter worked at the World Trade Center construction sight from day one in 1966 through to completion in 1972.

"It was eerie, very weird. We went in and it was dark at about three o'clock in the afternoon. Soon as I was there we met the fire commissioner of New York. We were the first group of ironworkers in."

"I'VE BEEN HERE NEARLY TWO MONTHS NOW – since four hours after the towers fell. I'm sifting through what's left and sending it to the scrapyard.

I was in Brooklyn when it happened, working on the Jamaica train station. While I was watching the first tower burn I saw the second plane fly overhead. I was actually 10 floors up on top of a column we were working on. We were setting steel, my buddy and me. We stopped and watched. The smoke was already coming off the first building a thousand feet in the air.

I saw the second plane hit. I saw the ball of fire. I knew right away this was no accident. Then they got us off the steel right away.

Our job is one of the biggest New York construction projects going right now. It's for the new train that goes to JFK International Airport. Right away we got scared. And right away we went downtown to help. I just knew they needed help. I knew they'd need ironworkers.

The R-train that usually goes into Manhattan, the subway line that goes right underneath the World Trade Center, it wasn't running and still isn't to this day. So I couldn't take that. It ended up I had to walk from here, at 77th Street in Brooklyn, all the way to 9th Street. And then I caught a train that took me to Manhattan and dropped me off at 42nd Street. From there I had to walk all

A Diary *Between Friends*

GRAHAM HARROP'S VIEWPOR

Santa Claus
You sure have a lot of raindere!
do You REALLY need so MANY? HAVE
You ever thot of letting one or two go?
Do You reelize how much You coud
save if You SHUT THE WHOLE oper—
ashun down and went three WAl—mart?
Yors,
Gordon C.

SANTA:
i WANT A TOY TRUCK
AND A FIRE ENGEN AND
i ALSO WANT A RESPONS
TO MY oFFER of 104 A
SHARE FOR YOU AND THAT
MANGY BUNCH OF DEER
YOU CALL A TEEM. DOES
HOSTYL TAKOVER MEAN
ANYTHING TO YOU?
Your FRENd
Conrad B.

DEAR SANTA
Do Your Reindeer RELLY
FLY? You travel from city
to city and never lose a presint.
You are always on time and
make everybody happy. When
i grow up i am going to run
an airLine Like that.
YouR PaL.
Robert Milton

Statistic shows we've never had it so good

D o conventional economic mea-
surements, such as real annual
economic growth, overstate or
understate improvements in our
material well-being?

In the minds of many academics,
growth in real gross domestic product
per person overstates improvement in
human welfare because it doesn't take
into account factors like environmen-

GDP per capita," Prof. Van den Berg
notes.

While real annual GDP per capita
of the world grew by 0.80 per cent
from 1820 to 1900, the EILW grew by
1.02 per cent. Between 1900 and 1950,
GDP per person growth was 1.04 per
cent and the EILW increased 1.9 per
cent. And in the past 50 years, the
world's GDP per capita grew by 2.09

**Fazil
Mihlar**

soldiers

... relation to the troops

BY JAMES McCARTEN

TORONTO — A wealthy, publicity-shy member of one of Canada's most prominent families has been quietly donating more than $500,000 US of his own money to the loved ones of soldiers killed in Iraq and Afghanistan.

Now, Les Shaw wants someone to pick up where he left off.

In May, after U.S. President George W. Bush declared an end to major combat in Iraq, the 76-year-old chairman of Toronto-based oil services company Shawcor Ltd. decided to show his gratitude to the families of those in both the U.S. and Canada who died protecting democracy overseas.

"We in North America and other parts of the world, we take freedom for granted," Shaw, who now lives in Barbados, said in a recent interview.

"Yet here's these young fellows and their families who are making the ultimate sacrifice to sustain the freedom we enjoy."

Once he got permission and the contact information for nearly 250 families from U.S. military officials, Shaw sent each one a personal cheque for $2,000 US along with a brief, eloquent expression of thanks.

Through Canadian Forces authorities, he also made a similar offer of $2,500 Cdn to the families of the six soldiers killed in Afghanistan.

"It is too easy for many of us in North America to take our wonderful freedoms for granted; obviously, your loved one did not," Shaw's letter reads.

"Please accept this small token as a gesture of heartfelt thanks from an appreciative Canadian. Spend it however you think your fallen hero would want."

The letters prompted more than 100 heart-wrenching replies, many stuffed with family photos and other tokens of remembrance from grieving parents, widows and widowers whose anguish at

...y jerk you around pretty good," Shaw said of the letters, his voice softening. "They get to you."

Shaw never planned to publicize his mission of mercy. But when the American death toll in Iraq continued to climb past his established cut-off date of July 31, he decided to go public in the hope a like-minded successor would emerge.

"I think they'd find it gratifying, and as Shaw, whose 22-year-old nephew is in Baghdad with U.S. forces.

"I was proud to do it, and I trust that it will give [families] some help in this time of need, when they've lost their loved ones."

As of Friday, the death toll among U.S. forces in Iraq totalled 461, 211 of which have occurred since July 31.

Colonel Rick Boyd, the U.S. defence and air attache to Canada at the U.S. embassy in Ottawa, helped to ensure Shaw's project didn't run afoul of the U.S. department of defence's ethics regulations.

"When he made this offer, it was not long after the announced end of major combat operations, and we had no idea there'd be a continuing series of casualties in Iraq," Boyd said.

"I thought, what a generous gesture, to make a no-strings offer like that just because he feels a Canadian should do something for American servicepeople."

While making it clear the U.S. is not soliciting any help, Boyd said American military authorities would happily permit anyone of like mind and means to carry on with the project.

The donations were never meant as a political statement, Boyd added.

In exchange for the names and addresses, Shaw — whose younger brother J.R. is chairman of Calgary-based cable titan Shaw Communications Ltd — agreed to protect the families' privacy by blacking out surnames, addresses and other personal details from the letters.

The deletions diminish none of the sentiment. "Jason wasn't only my baby; he was one of my best friends," reads one letter in which a mother pledges to donate half of Shaw's gift to a local children's hospital "in the hope that it will prevent some

other parent from knowing the terrible heartache of losing a child."

The other half, she wrote, would go to the church where her son is buried.

"Please know that without the prayers and support of loving people like you we would never have made it this far," it continues.

"I take it day by day and I don't know if I will ever be happy again."

One of Shaw's cheques reached a single mother of three whose oldest son, an Airborne Ranger, died in Iraq. A former high-school dropout who spent several years working in an auto plant before returning to school to get a medical degree, she now takes care of Detroit's inner-city poor and knows a thing or two about hardship.

"My children lived through all those tough years with me; they understand sacrificing for what you believe in," she writes. "I would give my life if I thought it would bring my son home, but it won't. So I will carry on in his footsteps and continue to give my best in the work that I do."

Many other letters express astonishment not only at Shaw's generosity, but his nationality as well.

"I was in awe to know that someone across international borders has acknowledged my loss and has shown appreciation for a young soldier, not known by you, but whose life and actions were recognized as noble and honorable," writes a woman named Leslie, who lost her only son to the war.

"I cannot say enough of how your kindness has been appreciated and will absolutely never be forgotten."

Shaw himself insisted that he wasn't trying to compensate for Canada's refusal to participate in the war in Iraq.

"Ottawa and our people (there) have their right to express their opinions, and I think I have the right to express mine; this is my expression," he said.

"We've got a 4,000-mile border with the Americans; we live with them, we vacation with them, we work with them, they're our biggest trading partner. Once you get past that, you come back to what freedom's worth."

Canadian Press

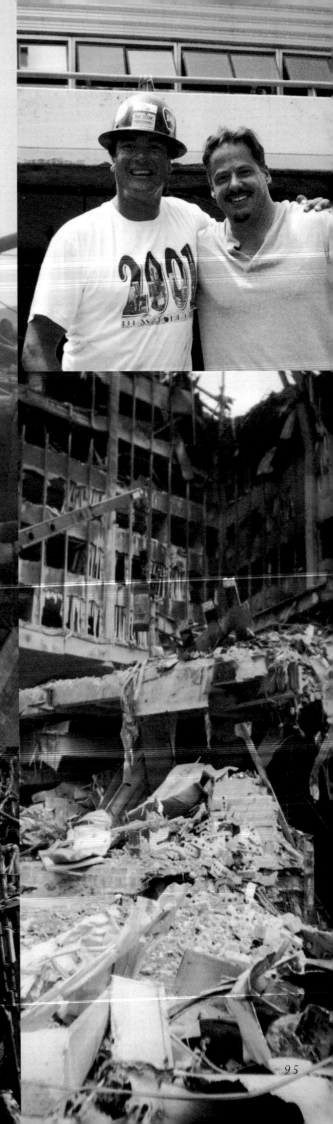

Photographs taken by Canadian steelworker Kyle Beauvais (in hard hat at right) intimately convey the magnitude of the devastation.

"They're giving us stuff — food, letters, cards, drawings. They're from kids at the schools, mostly. They're up all over the place at the site. I post them on the crane. They just say, 'Thanks.'"

the way to the Armory, where you get special papers to go into the site. It took a couple of hours just to get there. After we had our papers we all jumped in the back of pick-up trucks and went right in.

It was eerie, very weird. We went in, and all through downtown the lights were out. It was all dark at about three o'clock in the afternoon. Soon as I was there I met the fire commissioner of New York. We were the first group of ironworkers in. There were maybe 30 of us. I knew there'd be steel all over the place, and I knew they'd need guys who could handle it, who could put chokers on the steel — wire cables hooked up to a crane that picks the pieces up and swings them out.

We worked right around the clock, 'til the next day, maybe 'til about noon. Then I went home and slept and came back at nine o'clock that night. We worked around the clock again. And did that for weeks. All over the streets there was paper and six inches of dust on the ground. It was like something out of a movie.

At first there were just too many men there. Usually we work with six men in the crane gang, five men and a foreman. There, all of a sudden we had 16 men. We didn't know what anyone was cutting. People were cutting everything. There was just too many guys trying to help. After that it went through the union hall, and they made it like an ordinary construction site. The first three days, nobody was getting paid. It was all just volunteers. And we were all fine with that.

I was the only one from Canada in that first group, but I know there are other guys from Kahnawake and Akwesasne down here as well. The tradition of steelworking as a trade on the reserve

started with our ancestors. It was the best work in town. It all started with a train bridge built on our reserve in the 1880s. The company putting it in needed guys to work on it, so they came to the reserve.

A lot of people have been asking about the work on the Trade Center, the idea of it coming full circle, with my uncle putting up the towers here and me taking them apart. He was a crane-raising gang foreman. Then he was the superintendent when they put the antenna up. I've worked on bridges he built as well, and a lot of other jobs. It's odd that he put it up and I'm sending it to a scrapyard. But I'm treating it just like another building. I have to so I can get over the shock.

I still look at it today — every time I look at it, you really have to see the devastation with your own eyes to believe it. I work out of a basket 30 floors up. We have the tallest crane there. It picks us up to a building across the street from the Trade Center on the west side. We're taking out a pack of five columns that flew out of the Trade Center and right into this building. It totally smashed it from floor 26 all the way down to 16.

When we leave the site, we've got strangers coming up to us shaking our hands. Every day I'm shaking someone's hand on the way out. Especially the New Yorkers. They're really, really friendly. They set up special points where they all stand. They salute us as we leave.

At the beginning there was literally thousands of them. And on the weekend there are still hundreds. They're giving us stuff — food, letters, cards, drawings. They're from kids at the schools, mostly. They're up all over the place at the site. I post them on the crane. They just say, 'Thanks.'" ∎

Robert Culling, a welder from Calgary, Alberta, was one of 60 skilled ironworkers, welders and steamfitters who volunteered in New York City.

"I WENT DOWN TO NEW YORK because, in my mind, you don't slap the Statue of Liberty in the face. The group of us was hoping we could help out at Ground Zero. As it turned out, it was just too chaotic; there were too many people at the site. We were ready in our gear and helmets, so we walked around the city to see if there was anything else we could do. At one point a little girl came running up to me with her arms open wide and wrapped them around my legs. Her mother came up to me crying and apologizing. She told me that this was pretty much their first time out of the house since the attacks and that her daughter was reacting that way because I looked like her father. They were still praying for him to come home. I couldn't quite take it, but I just said everything would be okay — even if it was just for that moment when she thought I was her dad and she was happy. Maybe that helped somehow. I don't know. I hope so." ■

Letter to the Canadian Embassy in Washington

"I was a passenger...en route to Washington-Dulles when we were advised that we would be landing in Stephenville, Newfoundland. When we were able to depart the aircraft, we were met by police and the Canadian Red Cross, and there were almost as many volunteers as there were passengers and crew, even at 4 a.m.!

The outpouring of support and concern from these individuals was tremendous.... No request was too great.

It was with great reluctance that I reboarded the plane to return to London...."
—Sandra, Sterling, Virginia

Dr. Jim Young, Ontario's chief coroner, was called down to New York City to offer what help he could at Ground Zero. He worked with the Canadian Consulate to help families cope with their loss.

"NEW YORK CITY, from a series of short visits, before September 11, was to my mind never an easy city to know. But spending time there after that built a lifelong emotional bond. You can't visit Ground Zero, meet the families and see the faces and not be affected by it.

I got the call to go down to New York on the Thursday after the attack. The Province had offered New York any assistance they might need. We took an OPP plane, and by the time we arrived that night, there was literally no one on the streets, not exactly a normal Friday night in NYC.

The New York State Armory on Lexington Avenue was one of the city's few centres of sustained activity. For the families and friends of the victims, the Armory is a safe place to gather, to silently study the makeshift memorials. That first night, there was very little conversation. People wandered about looking at the photos, carrying signs and asking if anyone had seen their loved ones. My role in helping these grieving families is captured well by our motto at the coroner's office in Ontario: 'We serve the dead to protect the living.' That means no death should be overlooked. And it means we learn from death in order to make society a safer place. I've been through a number of disasters and learned from every one of them. In that sense, I'm here for the families, and to make sure they, as families, are giving all the necessary information to the American authorities to increase the chance for identification.

Often the families were asking questions that the officials hadn't yet considered, like

"I just said everything would be okay — even if it was just for that moment when she thought I was her dad and she was happy."

09-24-01

Prime Minister Jean Chrétien meets with President George Bush, prior to Chrétien's visit to Ground Zero.

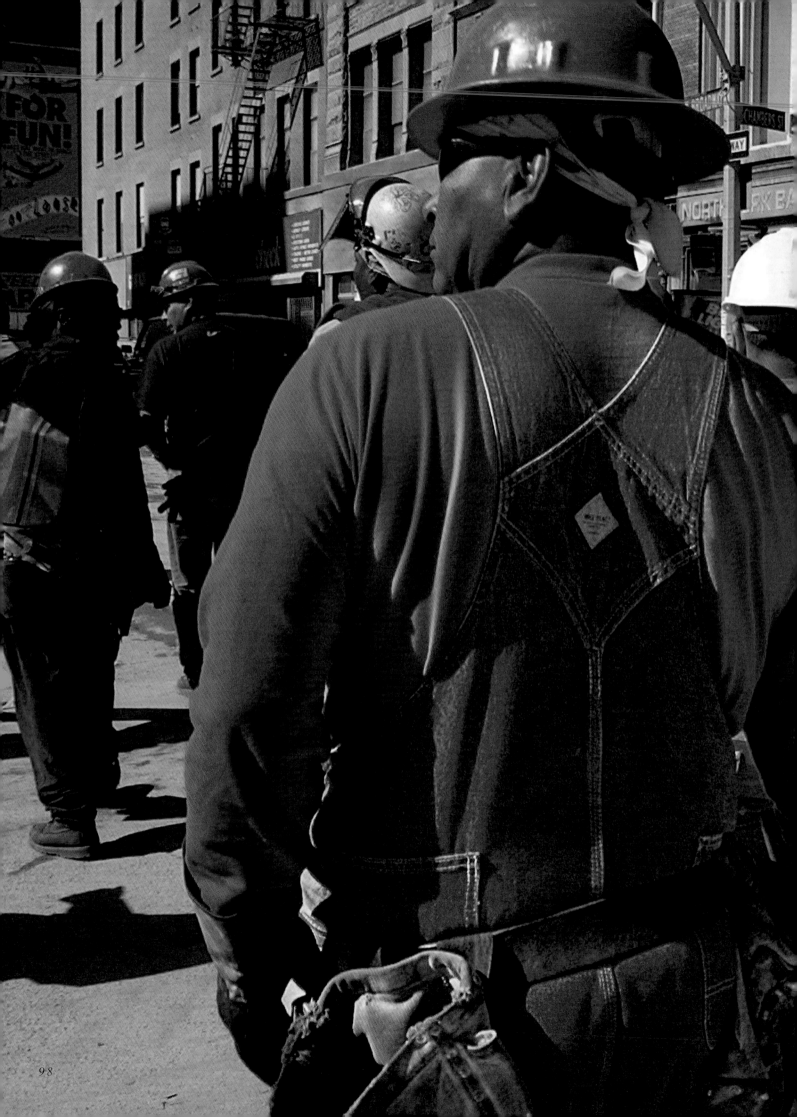

09-12-01
Ironworkers from Kahnawake, Quebec: Chester Goodleaf (left) and Roy Phillips, with a Mohawk sticker on his hard hat, join the volunteer workforce at Ground Zero.

99

"'We serve the dead to protect the living.' That means no death should be overlooked. And it means we learn from death in order to make society a safer place."

how and when they could collect the death certificates. The Americans were grateful for the communication of concerns back and forth in this way. And they were appreciative of any insights we could offer, though I'm sure they would have come to them themselves — these questions arise naturally and inevitably.

The families affected by the New York tragedy are certainly grieving. But they're asking the right questions at the right time — the questions we were sent to answer. They want to know that there is very little chance of finding any remains. They accept that their loved ones have perished and are asking when it's appropriate to hold memorial services. They recognize that these things matter, that memorial services draw friends and family together and allow the grieving to begin.

The first principle in a disaster of this magnitude, after the rescue phase, is to offer support and earn the confidence of the people affected. A good part of it is simply to listen. People get talking about their loved ones' likes and their dislikes, what their hobbies were, who their friends were.

In one family I remember, the father got a call from his son trapped inside one of the towers. He told me he knew immediately from the tone of his son's voice that something was terribly wrong, that this was very different from any other phone call he'd ever received from his son. This was a goodbye.

On the Sunday of my third trip to New York a service was held at Ground Zero for the families of those who had perished there. It was a memorial for 4,100 people from 80 countries. The families had previously been

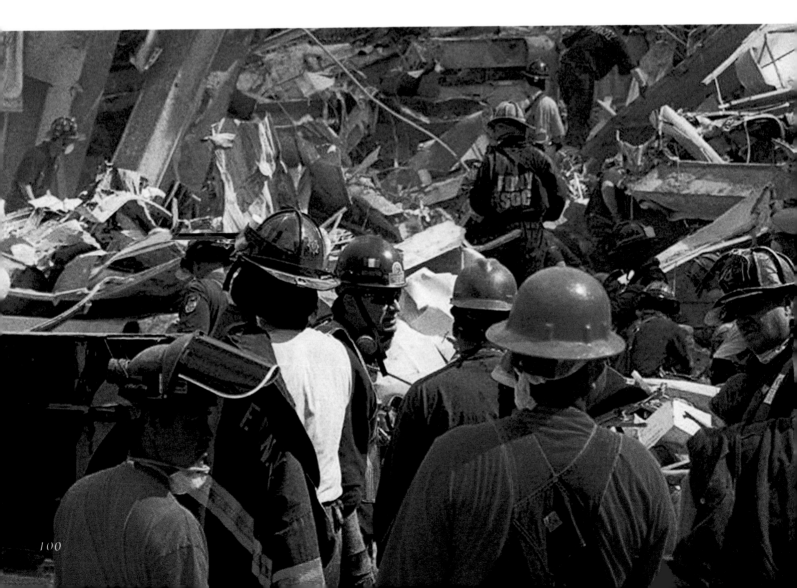

close to the site, but had never been allowed to visit what was in essence a tomb.

Most had brought friends to support them, and everyone had the required badge to get onto the site. The closest relatives also had a purple sticker on their badge, signifying that they were to receive an urn of soil from Ground Zero.

As the service began, the sky was blue and the sun was shining. The streets and buildings around the World Trade Center had been cleared and cleaned, and much less remained of the grey ash and cement dust that covered everything on September 11. Still, it was a war zone. The clock of a nearby church was stopped in time, recording the exact moment of the tragedy. The stage with its ring of flowers was in sharp contrast to the burned-out building that stood immediately behind it.

The entire place was spilling over with families of the dead. These are the times when it really hits home. Throughout my days in New York I tried to maintain a professional bearing, but at that memorial service it all came apart. It became personal. Because by that point, having spent so much time with the families, you almost feel that you knew the people whose loss they are mourning.

The service ended with the sunlight darting in and out between the buildings and the temperature noticeably colder. Andrea Bocelli sang a mournful but glorious "Ave Maria." Unfortunately, this isn't a tranquil or even a restful place. It's a place to contemplate wrenching questions about who we are and who we will become in light of September 11. What we ultimately must decide is whether Ground Zero will represent hate and despair, or tolerance and hope." ∎

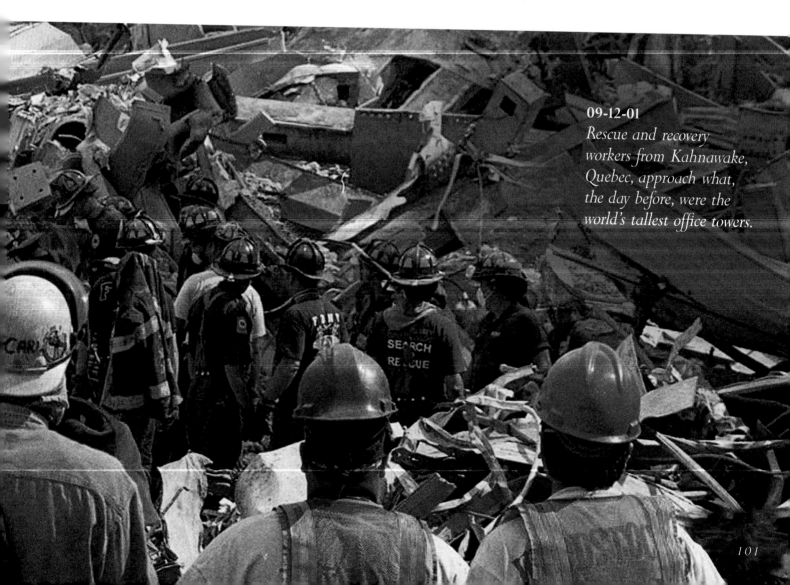

09-12-01
Rescue and recovery workers from Kahnawake, Quebec, approach what, the day before, were the world's tallest office towers.

09-13-01

After a total shutdown of commercial aviation throughout North America, flights depart for the first time on September 13. A passenger jet flies over Montreal's Dorval airport, where a sign expresses something of the grave new world Americans and Canadians are faced with after the attacks.

OUR DEEPEST SYMPATHIES ARE EXTENTED TO THOSE WHO HAVE LOST THEIR LOVED ONES! CANADA

Going Home

Nina Bonner, a B.C.-based tour operator, was supposed to drive 12 American senior citizens to the Vancouver airport on September 11. By the end of the day, she was rolling along the Trans-Canada Highway. Sixty-two hours and 3,000 kilometres later, they arrived home in Iowa.

Nina Bonner, 39, Victoria, British Columbia
"THEY WERE ALL QUITE DISTRAUGHT when they found out they couldn't fly home. Everyone was crying, trying to get on the phone to call their family. The urge to go home at a time like that was just so overwhelming And I completely understood that. I told them not to worry, that we'd see this through together.

During the ferry crossing from Victoria to Vancouver, we found out all the airports were closed. A man was walking around the boat, spreading the news. At first we thought he was crazy, but a few of the women called home and heard the same thing. Then I called my husband at home. We were trying to figure it all out when he looked out the window and said, 'Well, we've got the old camper van in the driveway.' I put the phone to my chest and turned to the group — I just wanted to give them some hope. I said, 'You know, it'll all be fine. This is the worst case scenario: I could drive you home in my Dodge camper van.'"

Connie Overbergen, 65, Oskaloosa, Iowa
"NINA LOOKED AT ME and said, 'Connie, really, I'll drive you home.' I said, 'Nina, do you know how far Iowa is?' She said it didn't matter. She'd driven across Canada before. We said, 'Sold!' She went home and picked up her van. It was a big white van that she takes on camping trips up to the Yukon. It was exactly a 12-seater. She

"The urge to go home at a time like that was just so overwhelming. And I completely understood that."

09-13-01

Long line-ups await travellers leaving Calgary International Airport on September 13. Increased delays due to stepped-up security added to the prevailing air of anxiety.

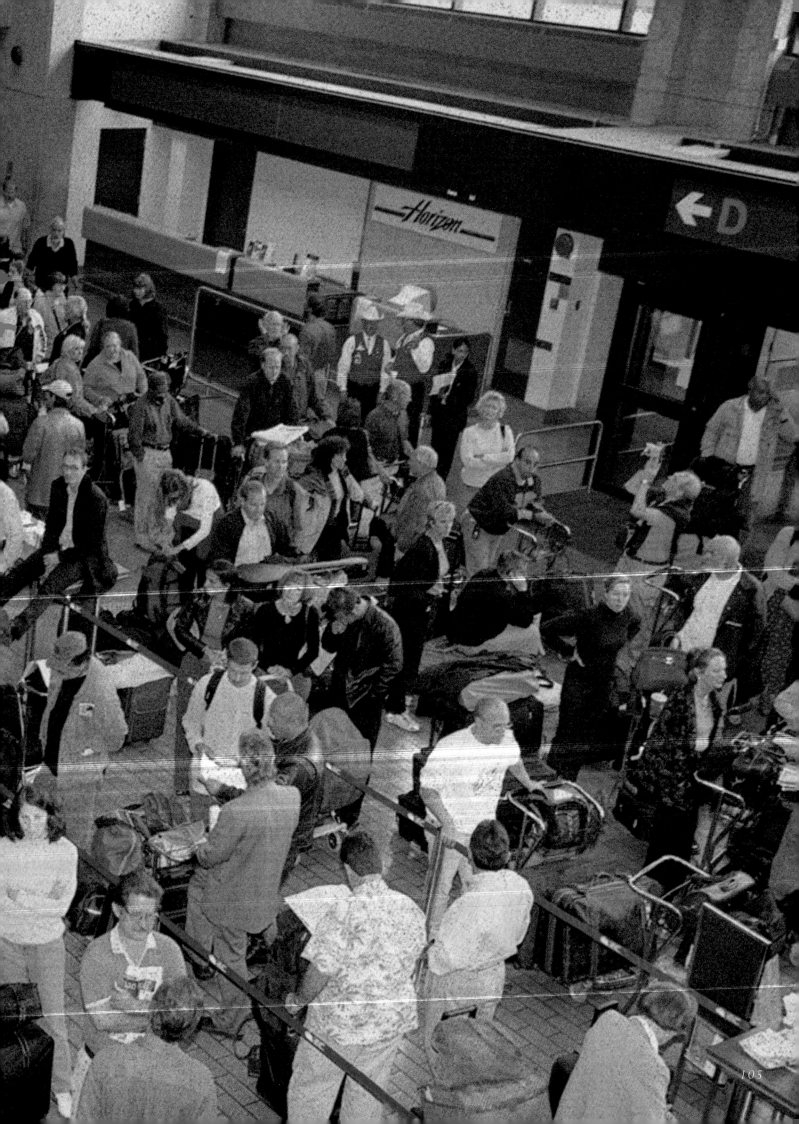

put all our bags on a rack on top. All I asked of her before we left was that we could stop somewhere to buy pillows and blankets for our trip. She said, 'Don't worry about it, I've got all that packed under the seats.'

Just as we were leaving Vancouver, my daughter in Texas called my cell phone. She said, 'Mom! Stay in Canada! That's your safest bet.' I knew she was probably right. We had heard the border was closed. But I said to Nina, 'Let's not worry about that now. Let's just head east.'"

Mary Anne Hesling, 71, Oskaloosa, Iowa
"IT WAS SUCH A GRACIOUS OFFER to take us all the way back. There were a few little problems about where people sat. The four seats in the back of the bus were the smallest and the most uncomfortable. We thought we'd all take turns there, but some people couldn't fit, so they couldn't take their turn. Nevertheless, we weren't going to complain. We just wanted to hurry up and get home any way we could."

Betty Harsh, 70, Oskaloosa, Iowa
"WE STARTED OUT TUESDAY EVENING at five o'clock. Nina thought we'd get to Radium Springs, still in British Columbia, by about two Wednesday morning. Because we had to go slower than expected through the mountains – it was pitch black – we actually didn't get there until 5 a.m.

Eventually everybody slept. Everybody except me, that is. If I can't lie down I can't sleep, so I just sat there. At the end of that first leg we checked into a motel in Radium Springs and had a nap for about four hours and then started driving again. We just kept going.

Initially I'd been wishing we hadn't taken that extra day in Victoria because if

09-14-01
Tour operator Nina Bonner (right, with her van) was scheduled to drive 12 American seniors to the Vancouver airport on September 11, but ended up driving them 3,000 kilometres home to the Midwest. These are snapshots taken en route.

"If I can't lie down I can't sleep, so I just sat there. At the end of that first leg we checked into a motel in Radium Springs and had a nap for about four hours and then started driving again. We just kept going."

A Diary Between Friends

6255·DJ

Holiday

09-15-01
*After the world's longest
undefended border was
re-opened, a seemingly endless
line-up of cars accumulated,
waiting to enter the
U.S. at the British Columbia-
Washington Peace Arch
border crossing.*

> *"About 30 minutes out of town, clear out in the middle of the countryside, all of a sudden the vehicle shut down. We'd run out of gas."*

09-15-01

Known locally as "the plane people," stranded passengers might just as easily have been nicknamed the "school bus people" — as school buses were the only means of mass transit available to shuttle them from the Gander airport and back again (below) as they began their journey home.

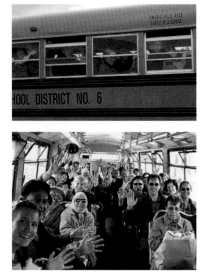

we hadn't, we'd have been home fine on the 10th. But the scenery, the sheep and the fields, were so peaceful. In one town where we stopped for lunch there were some American flags flying. We thought that was fantastic."

Betty Steele, 81, Mesa, Arizona

"WHEN WE HEARD THE NEWS of the attack, it was like getting the breath knocked out of your lungs. But there were redeeming moments. The glaciers at Banff were quite something. We only stopped for a few minutes, but right when we were standing there a piece of the glacier broke off. There was a tremendous rumbling noise, like a thunderstorm, and then a great big chunk of ice splashed down into the lake. We were fortunate enough to be there at exactly the right moment."

Jim Harsh, 78, Oskaloosa, Iowa

"WE HAD BREAKFAST the second morning – we were in a small town called Swift Current in Saskatchewan now – and we started driving at about five in the morning. About 30 minutes out of town, clear out in the middle of the countryside, all of a sudden the vehicle shut down. We'd run out of gas. We sat there for about two hours. It made me wonder whether we were ever going to get home."

Donald Johnston, 69, Pocahontas, Iowa

"WE WERE STUCK about 35 miles out of town. I remember it well because I was riding shotgun the whole trip. I looked over at one point and the gauge was on empty. I said, 'Nina, we're going to run out of gas.' She didn't believe me. She said the van was so old that the gauges didn't always register properly. She'd been banging her dashboard all the way

because she didn't think the needles were reading correctly. So with the gas, she figured from yesterday we still had half a tank. Then, about five miles down the road, the engine went boom bom bum bm bmp. She said, 'What's going on?' I said, 'Nina, we've run out of gas.'

It's these farcical glitches that make a road trip so much fun. When we ran out of gas, we'd all had three or four coffees, so several of us found the executive washroom out behind the van – women and men both. The other thing, of course, was that by the time we'd hit Vancouver after the cruise, we had no clean clothes left. Driving across Canada in dirty clothes, 12 people packed in side by side in a small space, wasn't pleasant. I was glad we still had a good supply of perfume and aftershave – that helped. And, remember, eight out of the 12 of us have known each other for at least 50 years. And four of the gals were sisters. So despite it all, we were having a hoot. Anyway, we're all retired, so none of us really had to be home.

The only thing that bothered me was the initial shock of the attacks. When we were at the hotel waiting for Nina to pick us up, we stepped outside for a breath of fresh air and witnessed, right over our heads, a Japan Airlines 747 flying in for landing with two fighter planes escorting it on either side. That really brought home the severity of the crisis we found ourselves in. I knew I was going to get home eventually, but at that moment, to be locked out of your own country was an experience that you really cannot fathom.

But I tell you, the Canadians were 110 per cent behind us. The flags outside the hotel went to half-mast immediately. The waiters in the bar were telling us how sorry they were. Canadians have always

been nice to me – I've driven across Canada to Winnipeg and North Bay for business, so I know the country. But, boy, on this trip home, they were super-nice."

Ted Overbergen, 71, Oskaloosa, Iowa
"LOOKING OUT and seeing all the Canadian flags at half-mast brought tears to my eyes. And everywhere we went, many of the Canadians you'd talk to had tears in their eyes too. While we were on the road, my wife, Connie, and I celebrated our 45th wedding anniversary. We got the whole gang together in the hotel room the last night. It was memorable, that's for sure. What I'd rather not remember is sitting in the back seat of that van the entire trip. Connie and I rode back there all the way because we were younger than some of the others. We distracted ourselves by looking out the window at Canada going by. We kept looking up at the sky and noticed that it was a clear, blue, beautiful sky all the way. Then we realized what was so striking about it: we were used to seeing contrails from the airplanes. But the entire way back, there was not one contrail to be seen. There were no planes in the sky whatsoever."

Beth Hamilton, 64, Minneapolis, Minnesota
"NINA WAS OUR SAVIOR. She got us out from under a very bad situation. We could have been sitting in the airport for days. We could've run out of money, run out of medication. As it was we had our own little pharmacy going in the van, trading pills back and forth. The 80-year-old couple ran out of their blood pressure pills. That could have been a serious situation. And there were no hotel rooms left to rent. I heard one hotel employee in Vancouver say, 'There's another busload

coming in from the airport. I'm taking four of them home with me.' If Nina hadn't offered to take us home to the Midwest, we would've been stuck.

When we were on the road, we kept a singalong going for hours. I remember the 80-year-old gal, Betty, suggesting that we'd better start singing songs or we were liable to bite each other's heads off. We were all so tired and cranky. Our feet were swollen from sitting in one position for so long. But we didn't want to stop. We wanted to get home where, despite what was going on, we'd feel more secure.

We crossed the border in a teeny tiny place, Estevan, Saskatchewan. We expected a full two hours of the customs officials going through all our luggage. But they just took our passports, ran them through the computer, and sent us on our way. They didn't touch our bags. I think they took one look at all the white hair in that van and knew that we weren't a threat to anybody."

Josephine Fageol, 69, Burlington, Iowa
"THE ONLY WORRISOME THING, really, was that I didn't have a passport. I'd never been out of the U.S. before. And under usual conditions, you'd never expect it would matter between the two countries. But now I thought, 'Oh my. What if they need me to prove who I am with more documentation than my birth certificate? I could be detained for hours.' But the officials said it didn't matter. A few of my girlfriends at home have asked about Canada and the road trip. I told them, 'If I were to live any other place, Canada would be it.'"

Sidney Smith, 74, Oskaloosa, Iowa
"EXCEPT FOR THE FIRST 24 HOURS of straight driving, I had a great time. But poor Nina, she didn't have cruise control on that old

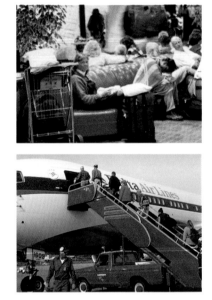

09-16-01

Regroup and reload: exhausted passengers wait to be processed at 3 a.m. for flights home from Gander, Newfoundland, (top) and then trudge up the gangway of a Delta Airlines jet (bottom) five days after the attacks.

09-15-01

A trio of Texans, Dana Melton, Judy Kontaratos and Jim Kontaratos, together with their host in Gander, Lisa Ivany (far left), just before they head home to Dallas.

"The whole trip was a bit of a twilight zone experience. But I have to say the Canadians were incredibly giving."

van. And for insurance reasons she didn't want to delegate the driving to anyone else. She got cramps in her leg from pressing the accelerator for so long. And she loaded and unloaded all that luggage. This gal was an angel."

Dave Steele, 85, Mesa, Arizona
"IT WAS AN EXPERIENCE ALL RIGHT. Once we got across the border, we had a little party in North Dakota. Then I called a friend who's got a motorhome and talked him into coming to pick us up in Minneapolis, to save Nina those last three hours of driving. He arrived with the RV all stocked with hors d'oeuvres. We dropped a couple of the ladies off who lived in town, said goodbye to Nina, and got going on the last leg."

Jean Chapman, 67, Forest Lake, Minnesota
"I WAS THE FIRST ONE to be dropped off. They said goodbye to me at a truck stop on the outskirts of the city so they could avoid the traffic. Connie sent me a snapshot she took, of me waving on the corner as they went on their way. There was a little grieving going on about parting. I felt a little tug of emotion, being the first one to leave the group. And I had to sit there for a couple of hours before my daughter was able to pick me up. Truly though, it was wonderful to be among familiar surroundings. The whole trip was a bit of a twilight zone experience. But I have to say the Canadians were incredibly giving. It felt like there were so many caring people in the world. I remember saying to myself, 'My goodness, these people are really reaching out.' Thumbs up for Canadians as far as friends are concerned." ■

A Diary *Between Friends*

09-13-01
A stranded traveller snoozes on the concrete floor of Montreal's Dorval International Airport while he waits for his rescheduled flight.

09-13-01
The first of 44 flights diverted to Halifax, Nova Scotia, is finally homeward bound to JFK Airport in New York.

10-08-01

Seeking to fulfil her motto, "All challenges squarely met," HMCS Charlottetown *prepares to join the allied forces in the Persian Gulf.*

"All Challenges Squarely Met"

On September 17, 2001, Canadian Prime Minister Jean Chrétien declared in the House of Commons that Canada is "at war with terrorism."

One month later, Tammy Saunders' husband, Master Seaman Patrick Saunders, was deployed on HMCS Iroquois. His ship, in company with HMCS Preserver and HMCS Charlottetown, set sail from Halifax on October 17.

"THE DAY PAT LEFT WAS HORRIBLE. It was pouring rain. It was the most depressing, grey day you could imagine. I stood on the jetty as the ships headed out to sea. My feet were glued to the cement. When the ships' whistles blew we stood there waving our Canadian flags. I watched his ship pull away and I started losing it.

I remember thinking, 'Oh my God, he's not going to be home for Christmas. He's going to miss my birthday, his birthday, the birthday of one of our children, Valentine's Day, Easter — everything.' And yet, all you have to do is look around to see that you're not alone. There are women who are eight or nine months pregnant with their first child. That is such a happy time and their husbands aren't going to be there. We've been told they'll be gone six months. I think it'll be longer. Realistically, as a military wife, you have to hope for the best but expect the worst.

I stood there for at least an hour until the ships disappeared. I just couldn't walk away. If you had talked to me earlier in the day, you'd have said, 'God, she's got it together.' But it was as though I was in a state of shock. It didn't really hit home until we saw the Prime Minister; until they started pulling in the ropes and I heard that last whistle blow.

Since Pat left, we've managed to keep in touch. We just got our e-mail

"It didn't really hit home until we saw the Prime Minister; until they started pulling in the ropes and I heard that last whistle blow."

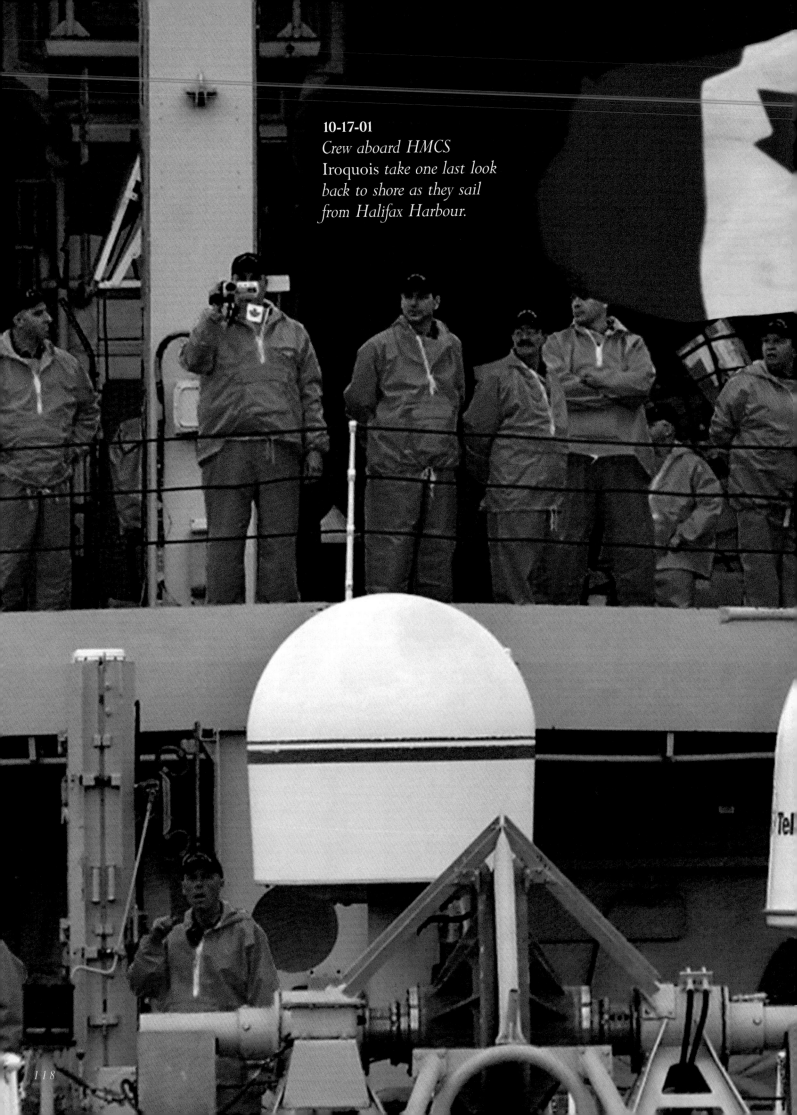

10-17-01
*Crew aboard HMCS
Iroquois take one last look
back to shore as they sail
from Halifax Harbour.*

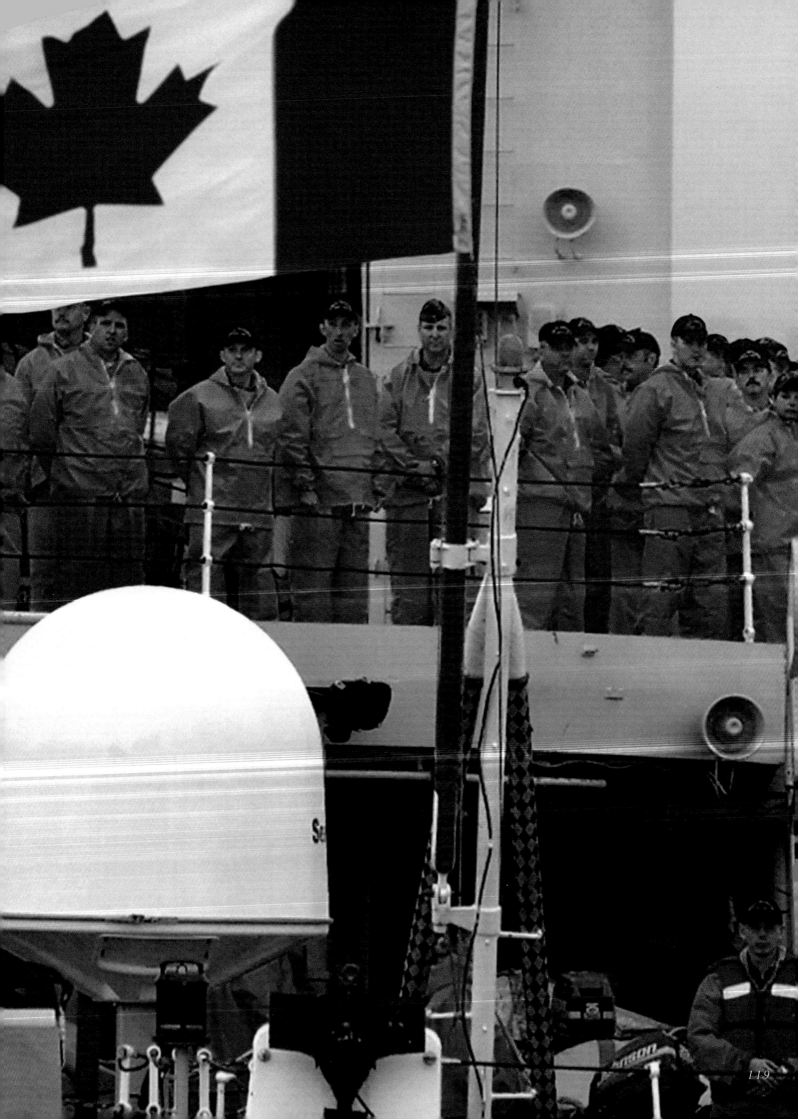

"'Pat, the day you left,

I was being strong and

it probably seemed,

by the way I acted,

like I didn't really care.

But I was keeping

it all inside. It was

when you were on the

ship and sailing off

that I really lost it.'"

10-17-01

Friends and families of Canada's sailors push against the railing, waving goodbye to their loved ones.

connection to the *Iroquois* up and running — for obvious security reasons we can't send things back and forth over Hotmail. And he's been able to call a few times, though they're short conversations, two or three minutes at most. When we spoke, I said to him, 'Pat, the day you left, I was being strong and it probably seemed, by the way I acted, like I didn't really care. But I was keeping it all inside. It was when you were on the ship and sailing off that I really lost it.'

Even though I was holding myself together, Pat's actually a pretty emotional guy. You'd think you were talking to Ann Landers or something. It breaks my heart to think about it. Earlier, on that day he left, he was the one who was really choked up when I dropped him off to report for duty. He was driving the van and he kept taking my hand and putting it on his cheek. I knew he was getting weepy. I hugged him and said, 'This is going to be okay.'

I find the emotions seem to come and go in waves. The week before they leave, everybody is starting to get on edge. Pat didn't really know the nature of this deployment. He figured that he'd go, but when the word came down it was still somewhat unexpected. He'd been on a course out in B.C. He called me and said simply that he'd be sailing, and that he was flying home to Nova Scotia that evening. A couple of days later the families of the *Iroquois* crew were briefed. They don't tell us exactly what they'll be doing. We know he will be aboard the ship, patrolling the Persian Gulf. They also give the families advice at these meetings. Because of the danger and unpredictability of this deployment I was told I should get a power of attorney — just in case.

Things like that definitely worry me, but if I sat and stewed about things I can't

10-17-01
A child perched shoulders above the crowd waves after the warships.

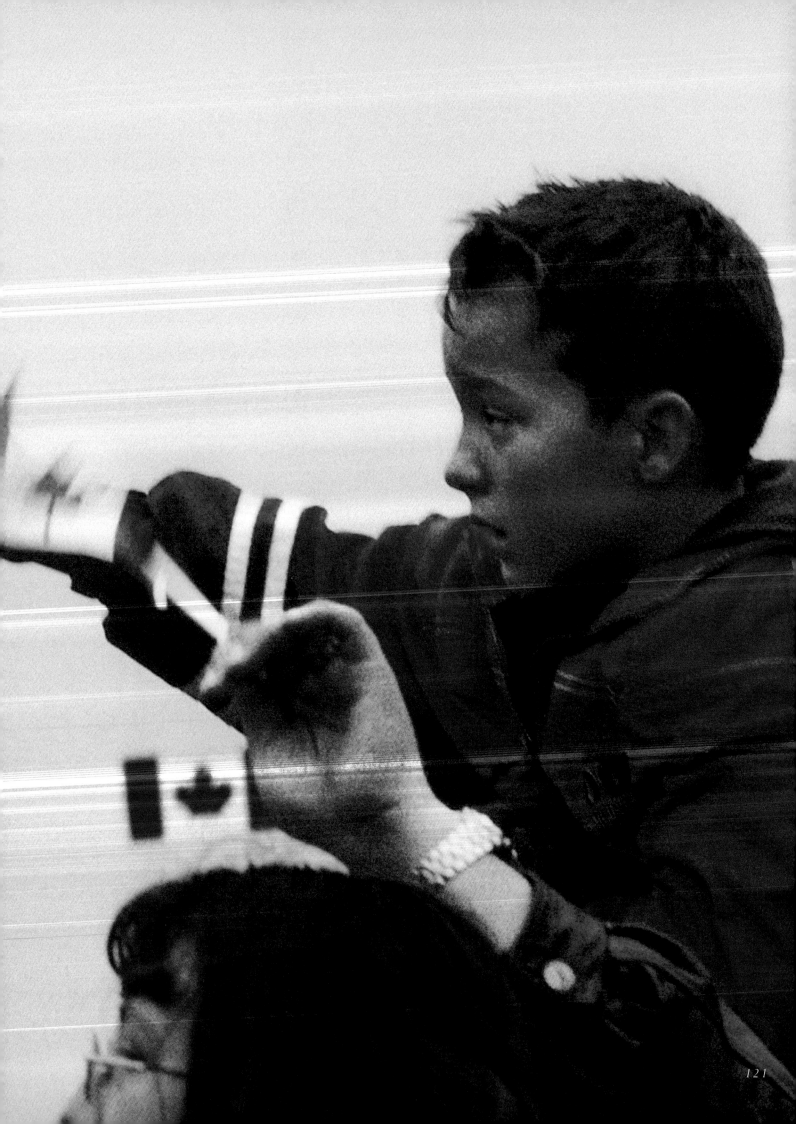

A military couple
kisses under the bow
of HMCS Preserver
before the ship
leaves port.

control, I'd be a basket case. It's important that I maintain an optimistic perspective, especially in front of the kids. My oldest son, Christopher, is 12. He's very curious and asks a lot of questions. He says, 'Mom, do you think they're gonna be in danger? Will they have to come off their ship? Will they be firing missiles?' He's also been coming home with rumours that circulate at his high school. The other day he asked if he was going to be drafted when he turns 16. I told him, 'Christopher, no, you don't have to worry about that.'

Our two youngest children are also having a tough time. Pat and I have experienced deployment before. But the little ones haven't. And because there's so much hype on 'the war,' they're concerned. My six-year-old, Zoë, is a very independent little girl. But last week at school, they were talking about the Remembrance Day assembly. Their teacher was explaining to them why we have Remembrance Day, talking to them about the soldiers and military personnel who lost their lives on our behalf.

Now, Zoë is a real tough little nut, but she's the only one in her class that has a parent who's gone to war. So among her friends, she's all alone in this. Her teacher told me that when they were talking about Remembrance Day, Zoë's face flushed and she was clearly shaken. Ever since that, she's been very clingy. If you knew Zoë, you'd know that's not her. She's a very spirited little girl. She was obviously worried that something's going to happen to her daddy. I try to tell her things to ease her mind, but you can only tell a six-year-old so much. I show the kids on the globe where Pat's going. I say, 'Daddy's over there doing his job. He won't be home for Christmas. But he's got angels looking after him.' The kids get little updates from him when he calls. He says he's fine and that he loves them and misses them.

This morning when Pat called he was telling me they're running them ragged, drilling them to death just to make sure they're totally prepared. They're only sleeping about four hours a night. He said, 'I'm so exhausted. I'm lying here in bed and it's the emptiest feeling. I look above and all I see is grey steel, I look on either side and there's a grey locker, a grey wall.'

Nevertheless, Pat and I both feel that serving is the right thing. Both Pat and I were army brats – both our fathers were in the service. Throughout our fathers' entire careers, they never had to face a war – thank God. We've gone so long without a war. But that's always in the back of your mind when you sign up.

When we found out he was leaving, Pat actually said to me, 'If I hadn't been called to serve with my ship, I would've volunteered.' And I would have agreed and supported him. I would stand behind him. He sees it as a freedom fight. I think he feels that if nothing is done now it is only going to get worse. He would say, 'Nobody likes war. But we've been called. The Americans need us, and we'll be there.' It's true, the Canadian services are much smaller than the U.S. military, but there is power in numbers, even if we're only contributing a few ships. Those ships just might make a difference. That is our purpose. We're here to protect our country. Even if – God forbid – Pat lost his life, I think it'd be the way that he'd want to go. He would be proud and I would be proud, knowing that he died making a difference." ■

"When we found out he was leaving, Pat actually said to me, 'If I hadn't been called to serve with my ship, I would've volunteered.' And I would have agreed and supported him. I would stand behind him."

10-17-01
*Three Canadian warships,
HMCS* Iroquois *(left),*
Charlottetown *(centre)
and* Preserver, *head off
toward the Atlantic.*

"To My Canadian Neighbors:

For days I have wanted to reach out and touch you, but distance and circumstances make that impossible. So this letter is all I have.

I am an American who lives far from the Canadian border. My husband spent many years in the military and spoke often of his respect and admiration for the Canadian Forces. I am also aware of the many quiet acts of courage Canadians have performed in the past to save American lives, but this time I have a tremendous need to let the Canadian people know how I feel and I hope that I speak for many Americans.

Since September 11, there have been hours of talk about heroes. There will be many more stories of individual acts of heroism performed by people in and out of uniform. I must at this time thank our Canadian heroes.

On Tuesday, September 11, Canada and her people acted swiftly with great courage and tremendous skill to receive all of those diverted airplanes. You had no way of knowing what harm or burden you were bringing on yourselves, but the possible risk was evident. I can only imagine the shock and fear that must have been in the hearts of the people who needed to act but act they did. So often in tragedy there are quiet heroes who require no praise, no boasting, no fanfare. Sometimes that's the mark of true heroes.

We all have family and friends that we love. They share our joys and sorrows, are present in our lives every day and are the very people to whom we forget to say: "Thanks," "I love you," "I'm glad you are a part of my life." I think of Canadians in that way, but today I especially want to say: "God has truly blessed America with Canadian neighbors."

—Forever grateful

Three of Canada's CF-18 fighter jets stand ready to patrol and protect the skies of southern Ontario.

Capt. Oliver

"My father, may he rest in peace, was Lieutenant Commander of a destroyer in the Second World War. He impressed on me from an early age that it is necessary to stand up for what is right and just. All you men and women of the Armed Forces heading for the Persian Gulf need to know that you are doing just that. My heart goes out to you."
—Gayl

"The strength it must have taken to willingly sail away from the shores of a tolerant and peaceful Canada is more than I can even imagine."
—Gillis

"We Americans are often not appreciative enough of our longstanding friends and good neighbors to our north. I think I speak for all Americans, however, in expressing gratitude for Canadian courage in standing shoulder to shoulder with us in facing terrorism — that implacable enemy without a face or nation."
—D.K., Fort Walton, Florida

"Thank you for defending our freedom."
—Teresa

"I read in the newspaper today that Canada has committed ground forces to help the U.S. with the war on terrorism that is being waged in Afghanistan. Putting your citizens in harm's way to ensure that freedom from terror is a way of life for all people is commendable. Please thank your government for me. You have stood beside us during many trials and tribulations through the years and please thank your people for being the true friends that they are."
—James, East Haven, Connecticut

"I am an American living in Boston, Massachusetts, and I just wanted to let you know that Americans appreciate your help very much. Thank you for your commitment to freedom and the fight against tyranny and terror."
—Mike

"Every Canada Day I watch on the Hill in Ottawa as our latest peacekeeping troops and our veterans march in the parade, I watch our air force's fly-bys, and our Governor General and the Prime Minister on their way to the event with a great sense of meaning and of belonging to something very real and very special — CANADA. We are to be counted on to help keep world peace, and when called upon, we protect our values and way of life. I thank you, your families and our nation for this. I pray you come back safe. *Que Dios los ampare.*"
—Ilma

"You know, the morning after you sailed off, the newspaper headline read: 'You Are All Heroes.' I guess no other words could express my sentiments quite so eloquently. I stood and watched from the jetty with my friends and loved ones and couldn't help but feel proud. Proud of you, my friends and companions, for fighting the good fight far from home, proud that you bring with you everything that is good in us and our country, proud, but frightened too. Come home safe. Fair seas and following winds."
—S. Lt. D.S.

"You brave men and women remind us all of what it means to be Canadian."
—D.M.J.

"I think I speak for all Americans, however, in expressing gratitude for Canadian courage in standing shoulder to shoulder with us in facing terrorism…"

10-18-01

In a bittersweet reunion, Leading Seaman Adriene Henry embraces her husband, Ogle, upon his return from a training exercise aboard HMCS Winnipeg *as Adriene prepares to sail for the Persian Gulf aboard HMCS* Vancouver.

Across from the naval
shipyard in Halifax,
Nova Scotia, candles
mark a peace vigil held
the night before three
Canadian warships set
sail for military operations
in the Persian Gulf.

"I am very pleased that we are standing shoulder to shoulder with our American brothers. Together we will ensure a better future for our children."

"…It is you, the men and women of this task force, who represent the values and moral fibre of Canada. It is your commitment that enables me to go to work every day and take care of my family. This tragic attack on North American soil has had a very deep impact on all of us. You are about to give back our focus and ability to stride forward confidently again. I am very pleased that we are standing shoulder to shoulder with our American brothers. Together we will ensure a better future for our children."
—Nick

"It gave me great pride to see our participation in the assault on world terrorism. We are a small force but a very well-trained one. The Canadian military always distinguish themselves during a crisis and will do so during this one as well. Good luck to you all, and know that you are doing the right thing."
—Ret. Capt. W.F.F.

"Words often fail me when I really want to express deep-felt gratitude and affection. Just let me say that your American neighbors to the south are so very grateful for your enduring friendship. Please know that you are in our thoughts and prayers as you stand shoulder to shoulder and heart to heart with us. Thank God for Canada. Thank God for your young men and women. I pray that each and every one of them returns safely to their beautiful homeland."
—Mary Snyder, Corbin, Kentucky

"You and others like you are our best hope for peace and security."
—André

"I'm lucky to be Canadian. I'm proud that you're defending our country and trying to save others. Thank you for helping us keep our country safe, and thank you so much for our freedom."
—Nathan, 10 years old

"I'm a Canadian teaching in a Florida school. Everything takes on a different perspective when a portion of every day is spent calming the fears of the young. Everything you do to help is appreciated more than a simple letter could ever express."
—Mo

"I'm a Canadian living in Manhattan and watched the towers fall half a mile away from my apartment. It was the worst moment of my life — it shook the security I have always known. But it did not destroy my spirit. As an adoptee of this city and a proud Canadian, thank you for your courage and loyalty to keep us safe."
—Monika

"I am Canadian-born and now I'm a naturalized American, and I can tell you that the American people are heartened and grateful for the support and unity shown by Canada. I'm proud of you."
—Ken

"The world has changed, but not the enduring friendship that marks the relationship between our two countries. It is a true friend that is willing to place his life in jeopardy for his friend."
—R.G., Lake Tahoe, Nevada

"Thank you for making a stand against those who would rather we lived in a world without freedom. I am proud to have Canada as a neighbor. *Vive le Canada.*"
—Lt. D.R., USN

"Your efforts and sacrifices are a tribute to the value that all Canadians put on our freedom. Had it not been for the past courage and determination of men and women like you, the past 50 years would have been unthinkable. Take pride in your devotion and hold your heads high, for those past men and women are among you today! There is no greater victory than liberty. There is no greater prize than freedom. This is the greatest cause of humanity."
—Joe

10-11-01
A C-130 Hercules transport plane takes off from CFB Trenton in Ontario, as Canada prepares to send three C-130s to join the American-led campaign.

10-17-01
A sailor salutes
HMCS Preserver
as she departs from
Halifax, Nova Scotia.

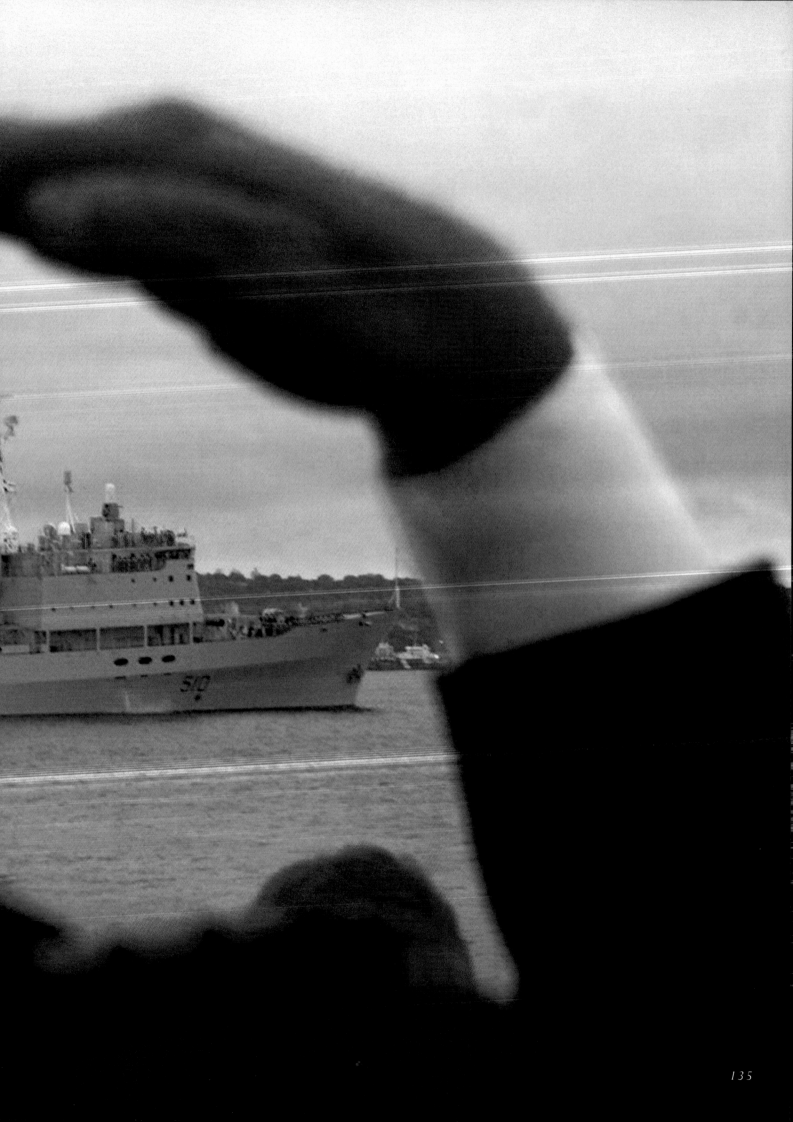

NEVER BE CLOSED

09-15-01

Flowers on a makeshift memorial, at the British Columbia-Washington Peace Arch border crossing, add emphasis to an enduring message.

09-14-01

Joining 100,000 mourners on Parliament Hill in Ottawa, U.S. Ambassador Paul Cellucci, accompanied by his wife, Jan, bows his head during the memorial ceremony for those who died on September 11.

September 15, 2001

THANK YOU, CANADA

"Deepest sympathies for a pain no country should feel."
—*from one of the many messages left at the U.S. Embassy's front gate*

September 11 is a date that will long live in the memory of every North American. It was the day multiple suicide terrorists struck at the very heart of the United States. They killed thousands. They forever changed the lives of many more. Our sense of security has been shaken. Our will, however, remains steadfast. Our principles endure. That day will also live in my memory as the day that I again learned the meaning of true friendship. That was the day Canada – its government and its people – collectively and spontaneously asked "what can I do to help?" And help they did – and still are. The Prime Minister called immediately, offering whatever was needed. This spirit was repeated again and again.

I have been touched, at times overwhelmed, by the outpouring of support. I know that Canadians were lost in the attacks as well.

Signs of support are everywhere, from the American flags that have sprouted up around the city to the many heartfelt words of comfort from friends, even total strangers. Seeing the proud Maple Leaf flying at half-mast in solidarity with our Stars and Stripes has touched us in ways difficult to express. People of all ages from all walks of life have somehow found their way to the Embassy's gate and those of our Consulates throughout Canada to pay their respects and offer a prayer. The flowers, candles, notes and mementos they have left have touched us deeply – a stuffed animal meant for "a child who lost a mommy or daddy;" drawings by school children, each with its creator's individual message; the devout Muslim's earnest prayers for the victims; the lines of people patiently waiting to sign the condolence book. These are images that will last forever.

They are images of a generous spirit, of unbounded kindness, and of the best of what it is to be human. The images capture the essence of Canada.

Tragedy has brought us together as never before. It has, once again, shown us that the differences that divide us are far, far less important than the ties that bind us.

Thank you, Canada.

Paul Cellucci, *Ambassador of the United States of America to Canada*

In Memoriam

for the Canadians lost

on September 11, 2001

Michael Arczynski

Garnet (Ace) Bailey

David Barkway

Kenneth Basnicki

Jane Beatty

Joseph Collison

Cynthia Connolly

Caleb Aaron Dack

Frank Joseph Doyle

Christine Egan

Michael Egan

Albert Alfy William Elmarry

Meredith Ewart

Peter Feidelberg

Alexander Filipov

Ralph Gerhardt

LeRoy Homer

Stuart Lee

Mark Ludvigsen

Bernard Mascarenhas

Colin McArthur

Michel (Michael) Pelletier

Donald Robson

Ruffino (Roy) Santos

Vladimir Tomasevic

Chantal Vincelli

Debbie Williams (Robinson)

Credits

(Image credits preceded by page number.)

2, AP, Jay Downs

6, Reuters/Getty Images, Shaun Best

8, Gander Academy Web site, photographer unknown

10/11, Halifax International Airport Authority, photographer unknown

12 (left), CP, Tim Krochak

12/13, Reuters, Andy Clark

14/15, *Halifax Chronicle-Herald,* Eric Wynne

16, Southam/*Vancouver Province,* Arlen Redekop

17, CP, Stuart Dryden

18, *Moncton Times and Transcript,* Greg Agnew

19 (top), *Moncton Times and Transcript,* Greg Agnew

19 (bottom), CP, Joe Gibbons

20 (top and bottom), St. Paul's High School, Gander

21, CP, Kevin Frayer

22 (top), Betsy Saunders

22 (bottom), Ken Arsenault

23 (top), *Halifax Chronicle-Herald,* Eric Wynne

23 (bottom), Gander Academy Web site, photographer unknown

24/25, Child's drawing

26 (top), Gambo Fire Department (Newfoundland), photographer unknown

26/27 (bottom), *St. John's Telegram,* Gary Hebbard

27 (top), Steve Kirby

28, CP, Kevin Frayer

29, CP, Mikael Kjellstrom

30, Southam/*Vancouver Province,* Nick Procaylo

31, Sharlene Bowen, Atlanta

32, CP, Darren Stone

33, Southam/*Ottawa Citizen,* Wayne Hiebert

34/35, CP, Grant Black

36 (top), CP, Ken Gigliotti

36/37 (bottom), *La Presse,* Bernard Brault

37 (top), CP, Alain Roberge

38/39, CP, Suzanne Bird

40, CP, Michael Peake

41, CP, Jonathan Hayward

42/43, CP, Denis Dubois

44, Reuters/Getty Images, Jim Young

45, Southam/*Vancouver Province,* Arlen Redekop

46/47, CP, Tom Hanson

48/49, CP, Fred Chartrand

50 (top left), CP, Darrell Oake

50 (bottom left), CP, Shaughn Butts

50/51, Southam/*Vancouver Province,* Arlen Redekop

52, Reuters/Getty Images, Andy Clark

53, CP, Grant Black

54, CP, Ken Gigliotti

55, CP, Ted Rhodes

56/57, CP, Wayne Arnst

57 (top and middle), CP/AP, Tina Fineberg

58 (left), CP, Derek Ruttan

58/59, *Montreal Gazette,* John Kenney

60/61, *Toronto Star,* Ron Bull

62/63, *"The Record — Kitchener, Waterloo,"* David Bebee

64 (top left), CP, David Bebee

64 (bottom left), *Vancouver Province,* Colin Price

64 (bottom right), Child's drawing from Blind River, Ontario

65, CP, Nick Brancaccio

66, *Montreal Gazette,* John Kenney

Endpapers photo
09-14-01
*A sea of 100,000 people gather on
Parliament Hill in Ottawa during
the National Day of Mourning for
victims of the attack against America.*

Page 2 photo
09-11-01
*Flags are lowered to half-mast
at the British Columbia-Washington
Peace Arch border crossing.*

Page 140 photo
09-26-01
*A clear view of the Woolworth
building, not visible from this vantage
point since the late 1960s, can
be seen through the ruins of the
World Trade Center.*

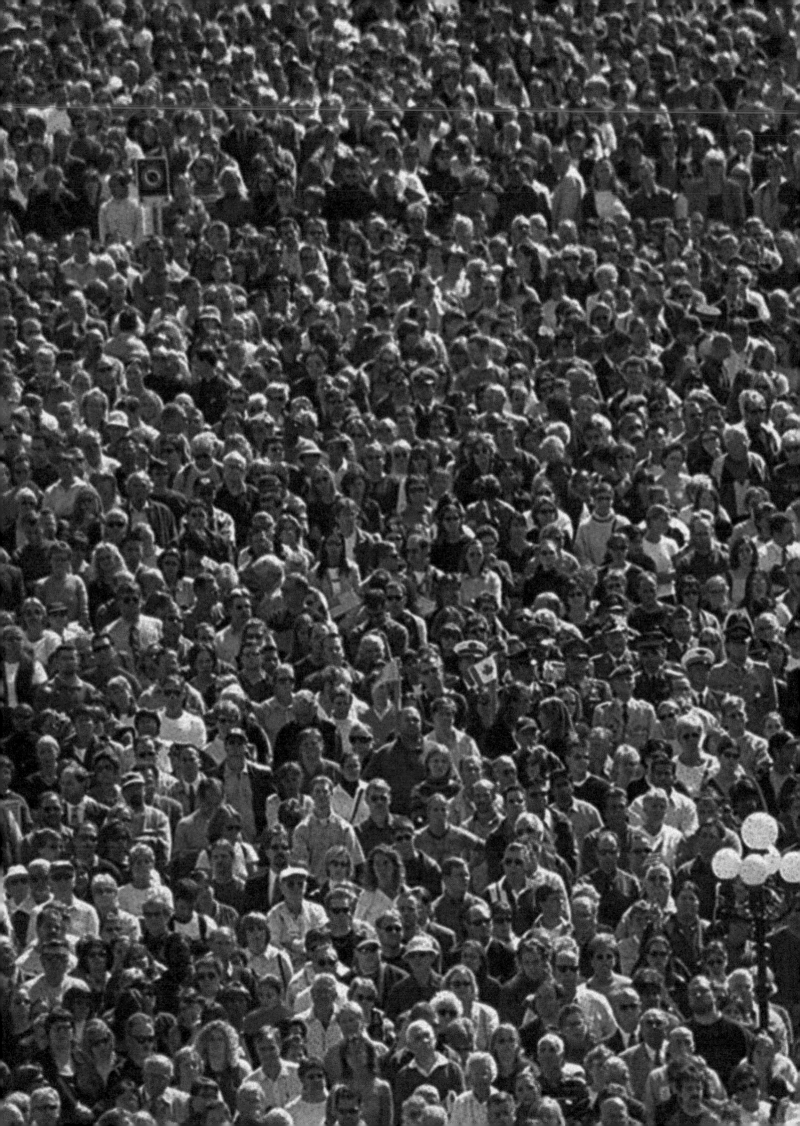